Rachel Owen

Illustrations for Dante's Inferno

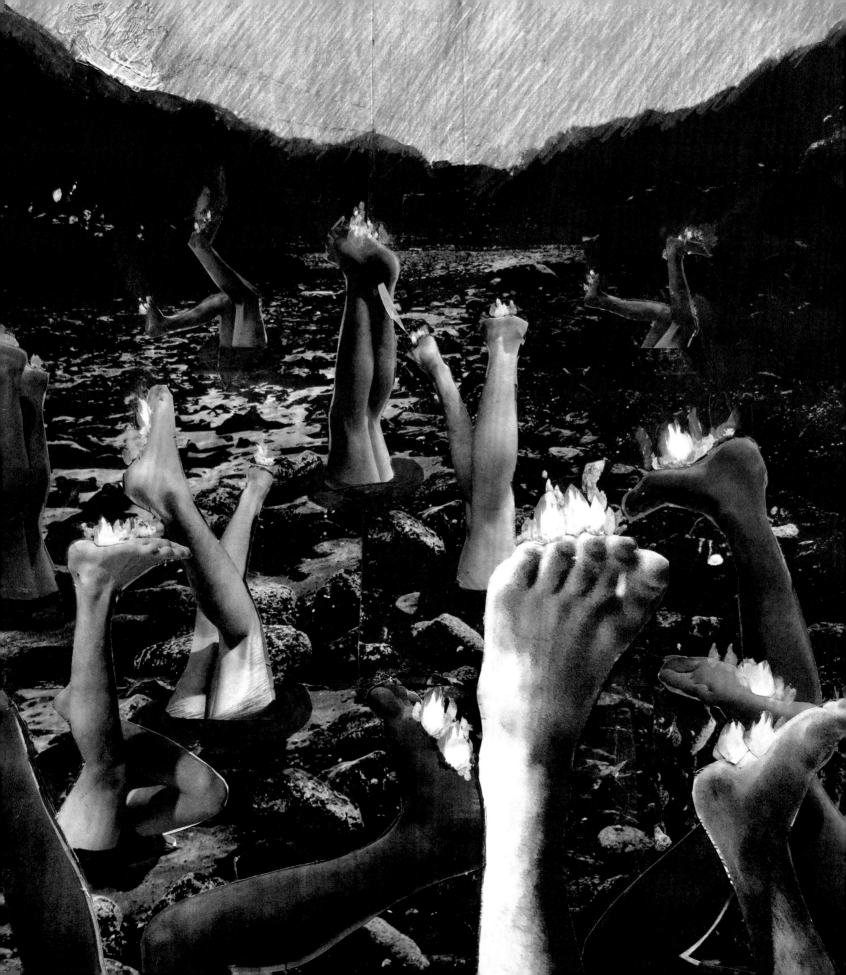

Rachel Owen

Illustrations for Dante's Inferno

Edited by David Bowe

This book is dedicated to Noah and Agnes

BODLEIAN
LIBRARY
PUBLISHING

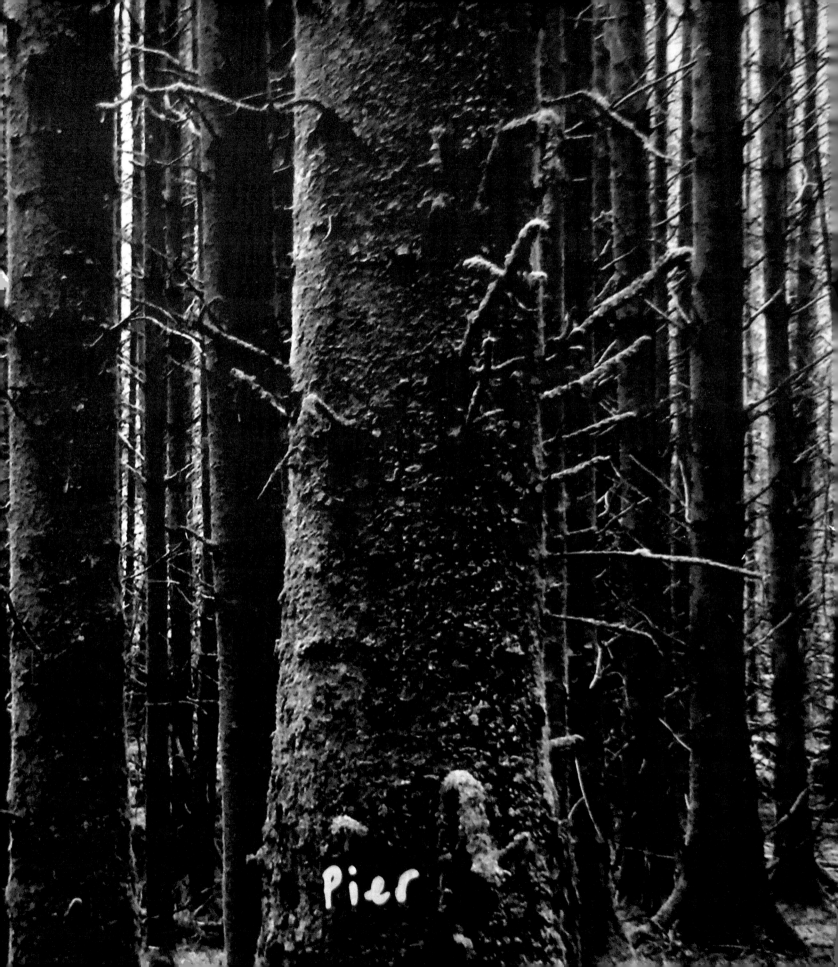

Pier

Contents

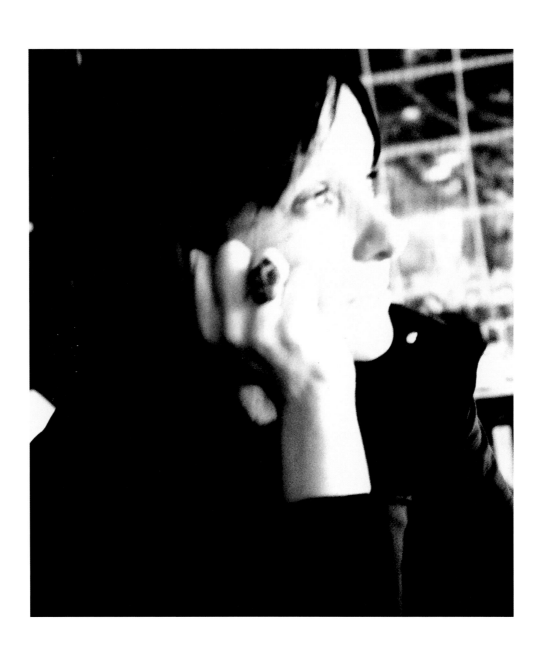

Rachel Owen 1968–2016

David Bowe

Rachel Owen was a visual artist, a teacher of the works of Dante Alighieri (1265–1321), and a researcher who produced valuable work on the visual culture arising from the *Divine Comedy* (the *Commedia*).

Her studies – an undergraduate degree in Italian and Fine Art at the University of Exeter, time studying painting at the Accademia di Belle Arti in Florence, and a PhD on illuminated manuscripts of Dante's *Commedia* at Royal Holloway[1] – represent a life and career in which language, literature and artistic practice were always in dialogue. Her PhD was followed by a research career during which Owen published articles on different aspects of the illustrative tradition surrounding Dante's poem.

One article, published in a 2001 special issue of the journal *Reading Medieval Studies*, discussed the reception of the *Commedia* by illustrators from the workshops of the fourteenth century to Sandro Botticelli's famous drawings produced in the 1480s and 1490s.[2] In this article, Owen charts the social and cultural milieu in which the earliest illuminators responded to Dante's poem. She also pinpoints the way in which 'the iconography of the *Commedia* that had been developed in the *Trecento* workshops was collected by Botticelli and repeated in printed editions of the *Commedia* throughout the Renaissance'.[3] This tradition clearly informs her own illustrations, which incorporate – sometimes playfully, sometimes monumentally – clear references to these early responses to Dante's poem.

Another of Owen's publications, a chapter in *Dante on View* (2007), deals with portraits of Dante, particularly the depictions of the poet within illustrations of his poem. In this essay, she both analyses portraits of Dante, from the conventions of medieval representations to Botticelli's 'realistic, recognisable, and definite portrait' in his drawings,[4] and engages with some of the more anachronistic critical reactions to this tradition. Owen challenges the disappointment of critics such as Richard Holbrook, who dismissed medieval representations of 'Dantes with pudgy, expressionless faces, Dantes with a feeble jaw and receding chin, Dantes in feminine form with feminine faces' as 'Protean' and not yet truly Dante.[5] This challenge is a call to re-evaluate the earliest portrayals of Dante according to the visual agendas and norms of their artists, and not according to a later vision of the poet as hero.

Rachel Owen in 2016.

Rachel Owen continued to undertake and present her research as part of the Italian Studies and History of Art communities at the University Oxford while she taught Dante to undergraduates, and she went on teaching into the final months of her life.

In her artistic practice, Owen came to focus on printmaking and she was involved with the Oxford Printmakers Co-operative. In an interview given to the Italian newspaper *La Repubblica*, Owen described the development of her work:

> Originally, I used more colour in my work, but then I came to understand that by limiting my palette to black and white I would actually feel freer. Someone once said to me that my pieces looked like stills from a film and I like the idea that each viewer can use them to create a film of their own, a story just for themselves, perhaps even using them as the starting point for some personal project. That's why the images I make aren't overly definite or too fixed. I like the idea of transformation, of an image that seems to change with your perspective, with a shift in the light or with how you feel in that moment.[6]

These ideas – of transformation and of still images that tell moving stories – both come to the fore in the *Inferno* illustrations.

Owen's illustrations visualize the transformations that take place in the text, most notably in the multiplying metamorphoses of the thieves in cantos xxiv–xxv, and also reconfigure elements used in her earlier work. The tower that casts its shadow over Owen's depiction of canto xxxiii, serving as 'l'orribile torre' (the dreadful tower) in Count Ugolino's tale of starvation and possible cannibalism (*Inferno* xxxiii, 4–75), has been repurposed from an earlier print exhibited at the Ballon Rouge Gallery at the 2015 Thame Print Art Show. These transformations of elements of her past work are reminiscent of Dante's own frequent acts of self-quotation and rewriting in the *Commedia* as well as in his other work.

In illustrating the journey through the afterlife, Rachel Owen's images also manage to present movement through still pictures. The individual scenes thread together to create the pilgrim's progress through hell. Meanwhile the viewer moves through the images either by passing from one to the next in an exhibition, or by turning the pages of this book,

participating in the movement of Dante's poem, the infernal journey.

In these illustrations we also see the range of expression that Owen is able to achieve with a predominantly monochrome palette, flashes of colour – the flower of canto II, the flames of canto XXVI – creating a greater impact for their exceptional status. It is only in the six *Purgatorio* illustrations discovered after the artist's death, and included after the *Inferno* sequence in this volume, that we see a real return to colour. Not full colour by any means, but, as befits the transition from the shadowy, lightless depths of hell to the optimistic shores of purgatory, the skies are now suffused with blue, with light, with the hope of what is to come.

Rachel Owen left behind a legacy of valuable scholarly insights, enthused students and engrossing artworks. The *Inferno* illustrations presented in these pages bring all these facets of her life and work together with reflections from friends and colleagues on her teaching at Pembroke College, her artistic practice and technique, and the context and impact of her illustrations, which represent a significant contribution to the history of Dante illustration.

vati fioretti dal notturno gelo/chinati e chiusi, poi che 'l sol li

In Memory of Rachel

Guido Bonsaver

These few paragraphs are devoted to a sketched, personal memoir of Rachel. I had the fortune to get to know her in the late nineties, when she was a graduate student at what was then Royal Holloway and Bedford New College (today's Royal Holloway London). Our paths then crossed again, by chance, in Oxford, where she became a colleague and friend during her years of tutoring at Pembroke College. There, she taught Dante's *Commedia*, all the way up to the last few weeks of her life when, since she was unable to walk to college, our students would visit her house in North Oxford. It seemed natural then that she should do so and, as a colleague, any thoughts of protecting her from the fatigue of teaching would instantly evaporate at the sight of her firm desire to continue to do what she enjoyed doing, passing on her passion for the *Commedia* to younger people.

It is not so very difficult to be a scholar, even in the celebrated field of Dante studies. What you need is time to read and the training and self-discipline to turn your acquired knowledge into a professional practice. What is difficult is to be, at the same time, a scholar, an open-minded intellectual and a good teacher. Rachel achieved this, and I witnessed it unfold, not in front of my eyes – I never sat in one of her classes – but through my ears, listening to what her students wanted to tell me about their time spent with her.

I witnessed it unfold quietly and smoothly, and those two adverbs have much to do with Rachel's personality. Even years back, when she arrived at Royal Holloway as a PhD student – I was then a young lecturer – she was one of those people who seem to walk on a thin layer of air: she would enter a room and move around with natural discretion, a light smile curving her lips; her dark, long hair, her dark clothes gave the impression of a fragile, whimsical creature.

Which was true. And it was not.

Once you got to know Rachel, one could not help noticing a more muscular side to both her personality and appearance. She was a woman of clear choices and stern outlooks. By the time we met again, at the local primary which both our children attended, the artist in her had been winning against the Dante scholar. She had shaped her art through a combination of her talents as a photographer and a printmaker. She knew and loved what she was doing but she was not the clichéd self-obsessed artist. No trace of narcissism

Detail from *Inferno* II: Virgil recalls how Beatrice enlisted him as a guide, Rachel Owen, 2016 (photographic print of mixed media collage).

nor of thirst for praise. It took me months before I saw, by chance again, some of her work hanging in a local restaurant.

Her love for Italian medieval literature had not been forgotten. It was dormant. I was then new in my job at Oxford, and once I realized that I could do with some help in teaching Dante, I put it to her and, next time we met, her mind was set. She was quietly pleased to reawaken the other half of her studies as a young woman. Her PhD thesis, after all, had been an attempt to marry those two halves – a study of early illustrations of Dante's *Commedia* – and now she saw the opportunity to revive the half which had been laid aside for years. In the context of Oxford's academic norms, it was an unusual move on my part. Rachel was far from being the scholarly type who guarantees exhaustive knowledge of the critical bibliography and is eager to develop her lecturing career. She did it for pleasure. And I had asked her for the pleasure of seeing her do it, and because something told me that she would be good at it.

And she was. Even statistically: our students sitting the Dante paper repeatedly did well in that particular exam. But that is not the point. That was being professional. Being good is something else. I discovered this in full once I came back after a term-long sabbatical break during which I had asked Rachel to take on some other parts of my teaching load. Unfussed by my request, she picked the bits she liked – Primo Levi, for example, unsurprisingly – and proceeded to do a memorable job. Here I am referring to my memory: it is indelible in my mind, the images and words of that first meeting with our students, once I was back, when I realized that their pleasure in seeing me back was outweighed by their loss of Rachel as their main tutor. I felt the stings of jealousy, of course. It was a strange feeling: I was happy to be jealous.

Rachel returned to her Dante teaching, and during the many times we met for lunch or for a cup of coffee or glass of something, I never asked about the secrets of her tutoring. But we constantly talked about our students. She was interested in how they were doing in other subjects; she liked to talk about their personalities, the different chemistries formed in each group. It was only years later – now it seems many years later – that, lacking her voice next to me, I decided to write to some of her old students and

ask for their views. And for their replies I thank Ellie, Nathalie, Emily, Patrick, Siân, Ollie and Rebecca.

Are there any common threads in their memories? On the whole, I can find three. First it is Rachel's ability to make their fears as anxious-finalists-facing-a-daunting-course evaporate in a few minutes. She did it with her calm, relaxed attitude and with her firm belief in their capacity to do well. The second thread is her infectious enthusiasm for Dante's work. Rachel loved to talk about the *Commedia*, to make it real. Every year, she took her finalists to visit the Bodleian Library so that they could get to know first-hand some of the very early manuscripts on which she had spent months of research as a graduate student. Their illustrations were her forte, of course, and every year I heard excited stories about this one-off school trip. Stupidly I never joined them, and now I never will. The third thread concerns Rachel's capacity to relate to them and to relate the medieval text to their lives, so that the parade of characters populating *Inferno*, *Purgatorio* and *Paradiso* would become *exempla* of humans with all their different traits, virtues and obsessions. The *Commedia* was first of all a journey through three very crowded places, with Rachel acting as a real-life Virgil, placing her students at the shoulder of Dante the pilgrim, making them equally curious about the strange and at the same time familiar litany of humans in all their shapes and mental colours. Of course, then came the study of Dante Alighieri's towering achievement in creating such a pulsating monument to medieval Christian culture and to his own dreams, fears and obsessions, and to his stylistic mastery. And then came centuries of critical bibliography, a sea of words which Rachel navigated not without a sense of irony, always weary of the by-products churned out by the unconscious adoration of, and desire for, the God-like, all-answering man (or woman, but mainly man, in Italian culture). In any case, by then, our students were in love with the *Commedia*; they moved through its cantos with ease and pleasure, and Rachel's work had been done.

Our students trusted her to the point that their own personal experiences – the highs and lows of late adolescent life – became the subject matter of their conversations. I was told of eager debates toing and froing between the text and their twenty-first-century lives: how the stinking innards of a siren (*Purgatorio* XIX, 31–33) mixed with the revelation of a boyfriend

who turned out to be different from what love at first sight seemed to suggest; of Rachel running with the provocation of Kanye West as a misunderstood Dante of our times. Rachel made them bend the *Commedia* to suit their feelings and imagination. It was literature as a thinking ground, as it should be.

As I said, Rachel's personality had a muscular side to it and so had her physical appearance. Her cheekbones, her nose, had a Welsh, earth-rooted quality that spoke of generations tilling the land rather than contemplating life by the fireplace. So did her thick-boned hands and forearms: no wonder she preferred to shape her art through manual labour rather than choose pen and paper and live the scholarly life in libraries. Riding Grouse, her favourite, mad horse, was another facet of this inclination for grasping life with her hands, holding on to it whilst galloping through the fields.

Photographed details of Grouse's black, silky body appear as parts of the centaurs in Rachel's *Inferno* artwork. If her PhD was an initial attempt to blend her twin love for art and literature, those thirty-four illustrations are Rachel's final accomplishment of that desire. Fascinated by them, I offered to help organize

their display as a special exhibition at Pembroke's art gallery. I did so before I had even seen them. This time acting as the college's art curator, it was another unusual move on my part, justified only by trust. We began to organize the exhibition but then her declining health got in the way. The muscularity and the energy of her body began to drain away. The last time we met, in college, as she asked, I saw her walking slowly through the gate, crawling almost, to the point that the porters got worried and later spoke to me. I could only say that, yes, she was ill, but equally determined to continue teaching and we could only accept her will. Rachel never made a fuss. She would rather smile and get on with her life.

Guardian angels do not exist, of course. But, yes, they do in other ways. Rachel's print of *Inferno* II is my favourite. It illustrates the canto in which Dante the pilgrim expresses, once again, his doubts and fears, and Dante the author articulates his literary ambition – his fictional alter ego emulating Aeneas and Saint Paul in his journey through the afterworld. But Rachel's imagination pushed all that macho stuff aside. The canto is also about not one but three women coming to the rescue of the frightened pilgrim, and

then there is a fourth, the biblical Rachel, wife of Jacob, who is only mentioned because she is sitting in paradise next to beautiful, soul-saving Beatrice. Rachel is a silent, mysterious presence in the *Commedia*. She appears four times but never speaks, nor is her symbolism made clear. Dante scholars, however, agree that her third appearance in the company of her sister Leah, in *Purgatorio* XXVII, makes her symbolic of the contemplative life as a higher state compared to the active life embodied by her sister. This interpretation kind of ruins my musings about our Rachel in her real life. But it does not clash with the image of her in my memory and in the *Inferno* II print. There, Rachel has collaged a close-up photograph of her face, unusually wide-eyed, looking straight into the camera. She is the fourth woman in the print, alongside the figures of the Virgin Mary, St Lucy and the guide. And, in her handwriting, one can read, just above the horizon of a darkened wasteland, one of the final tercets from the canto:

> *Quali fioretti dal notturno gelo*
> *chinati e chiusi, poi che 'l sol li 'mbianca*
> *si drizzan tutti aperti in loro stelo*

(Those little flowers, subdued and closed by the night's cold, straighten up and open wide on their stems when the sun lights them)
Inferno II, 127–9

Dante's simile of the opening flower – reflecting the pilgrim's reaction to Virgil's reassuring words – offers an unpretentious but powerful symbol of hope, of daily rebirth. The image of that opening flower, the only touch of colour, and Rachel's portrait are the focus of that print.

For this, and more, *Inferno* II has become a guardian angel, hanging above the staircase of my home. We can see it every day.

The *Inferno* Illustrations

Rachel Owen

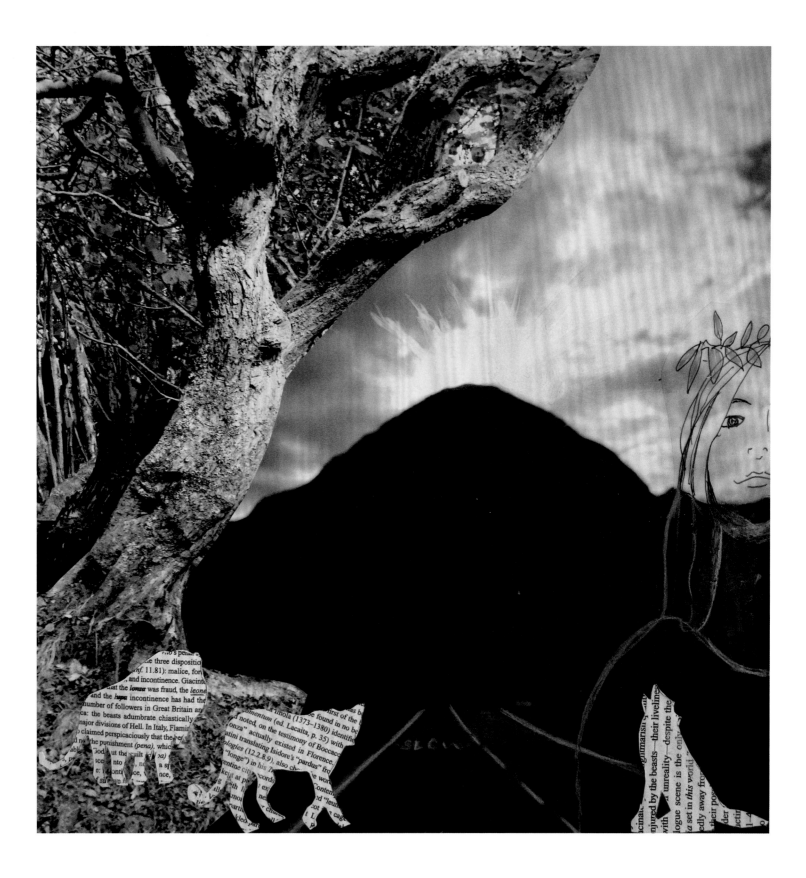

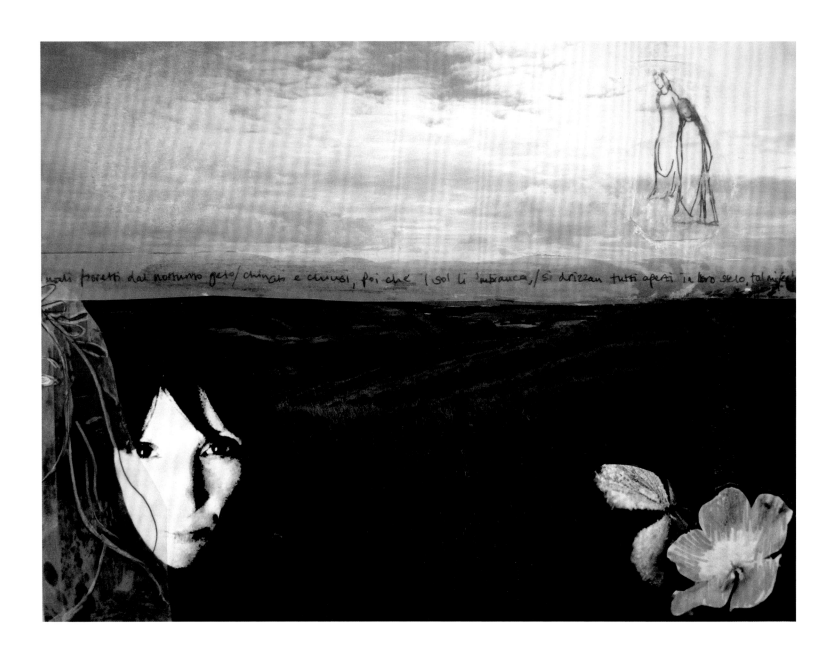

quali fioretti dal notturno gelo / chinati e chiusi, poi che 'l sol li 'mbianca, / si drizzan tutti aperti in loro stelo, tal mi fe'

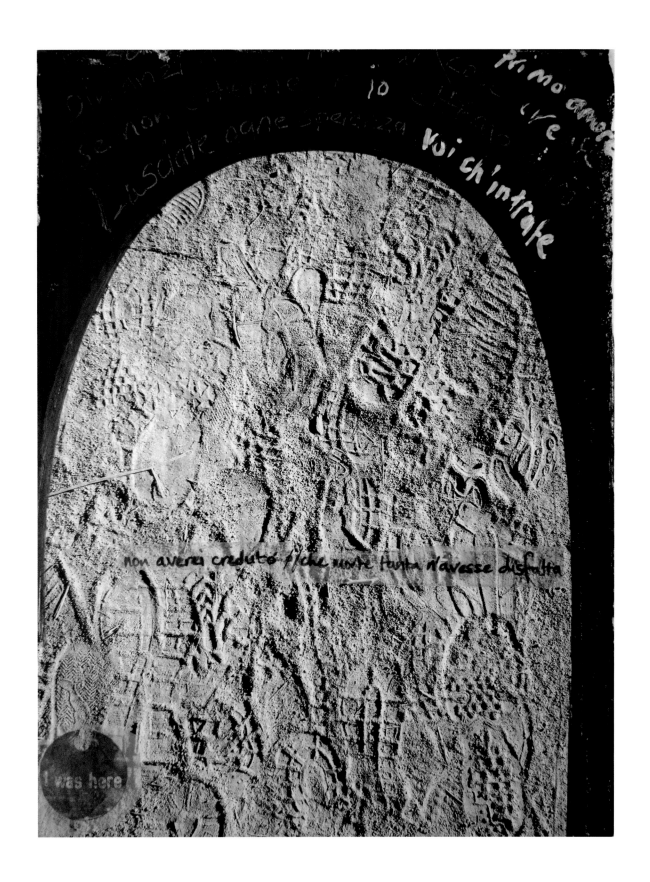

III

IV

Amor condusse noi ad una morte

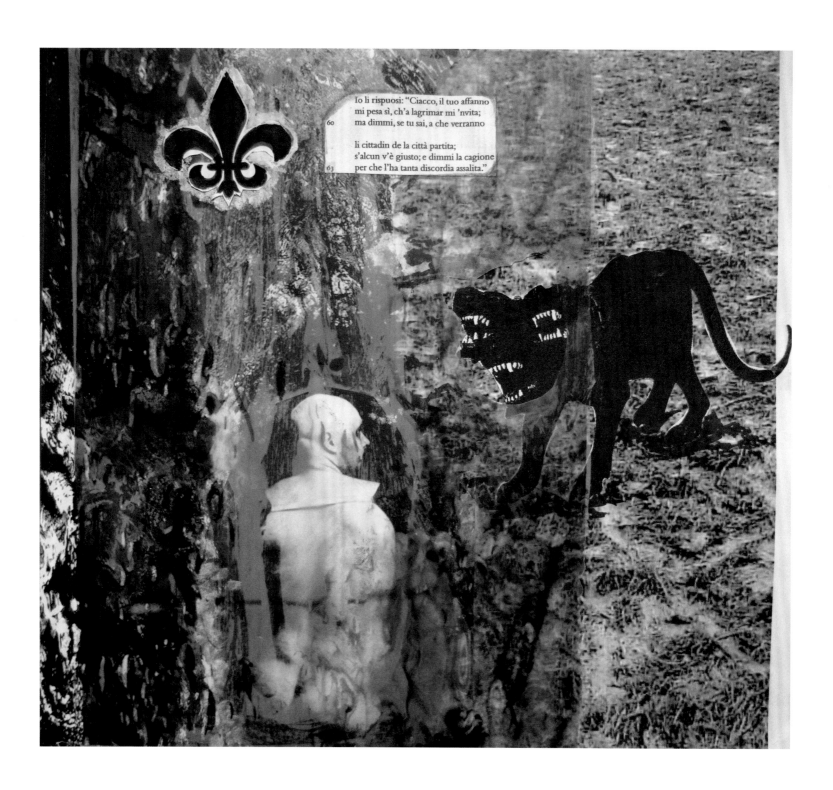

Io li rispuosi: "Ciacco, il tuo affanno
mi pesa sì, ch'a lagrimar mi 'nvita;
60 ma dimmi, se tu sai, a che verranno

li cittadin de la città partita;
s'alcun v'è giusto; e dimmi la cagione
63 per che l'ha tanta discordia assalita."

VI

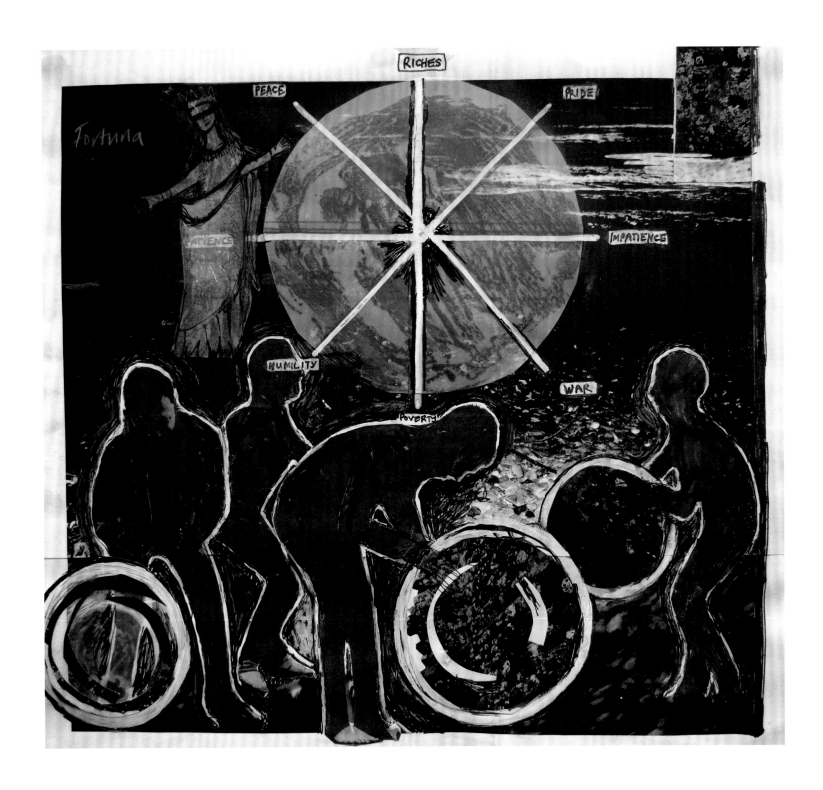

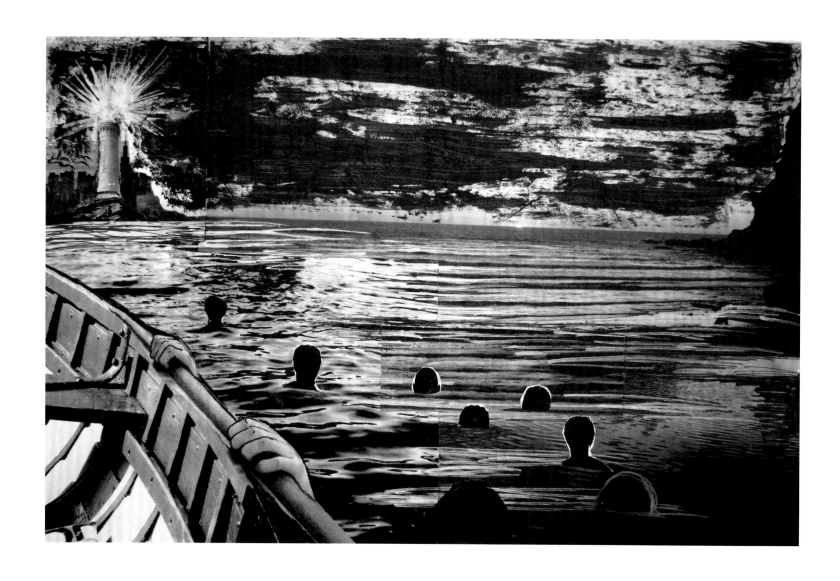

VIII

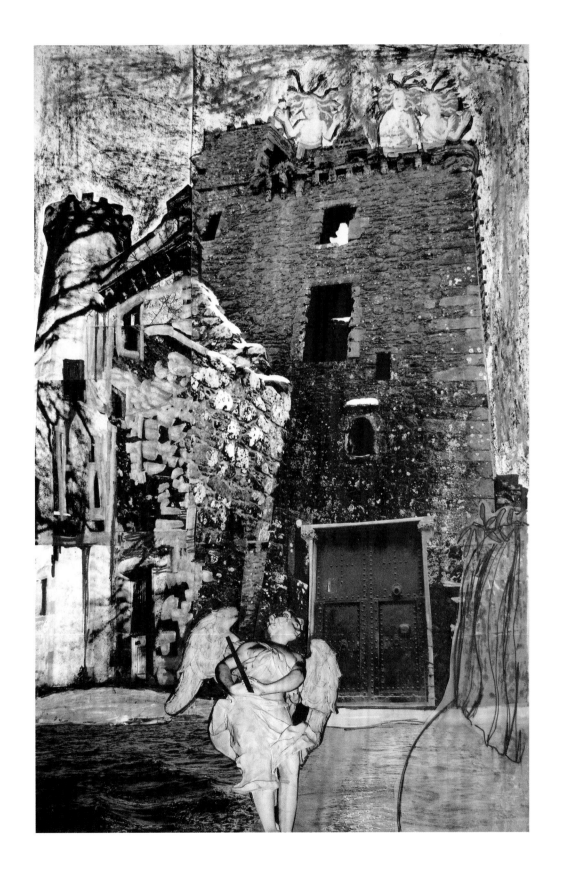

IX

X

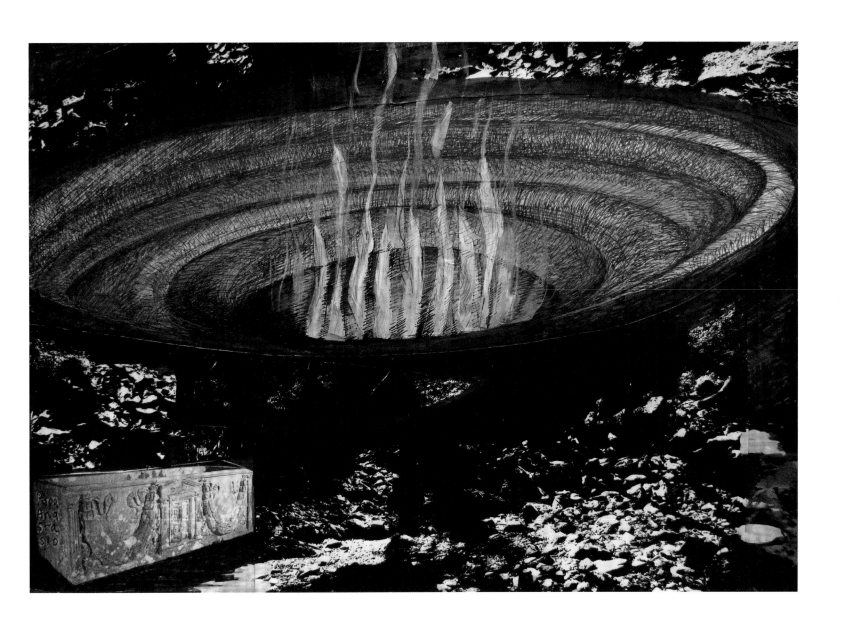

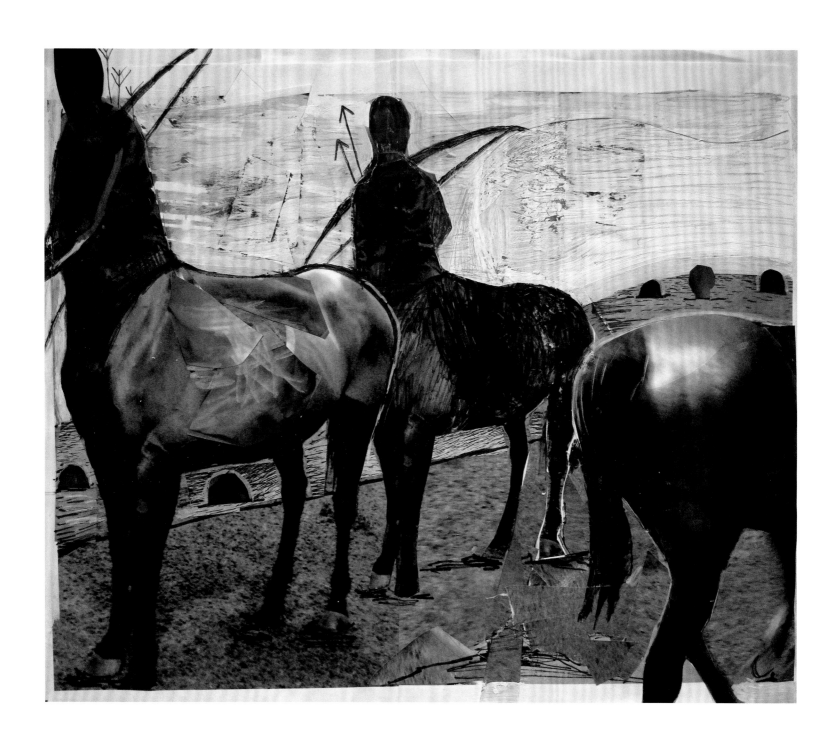

XII

XIII

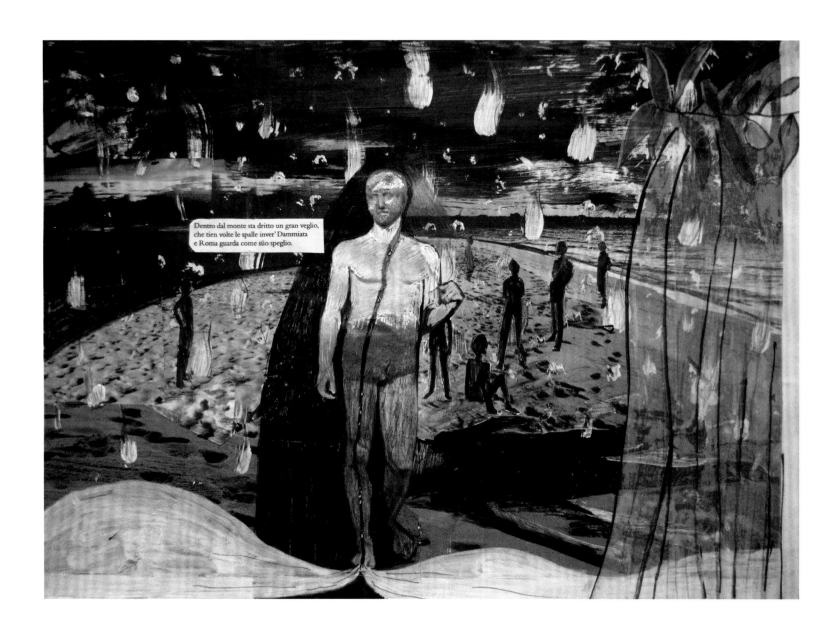

XIV

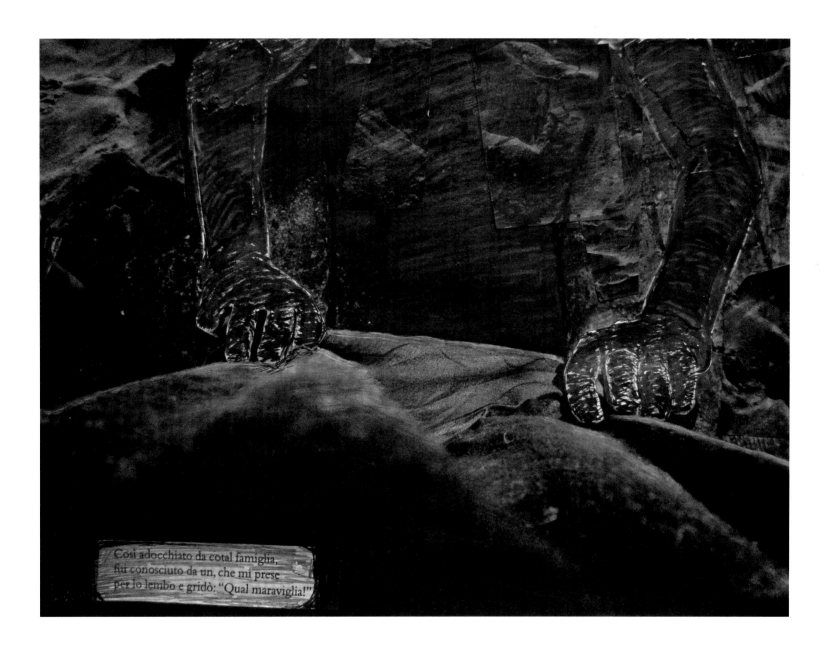

Così adocchiato da cotal famiglia,
fur conosciuto da un, che mi prese
per lo lembo e gridò: "Qual maraviglia!"

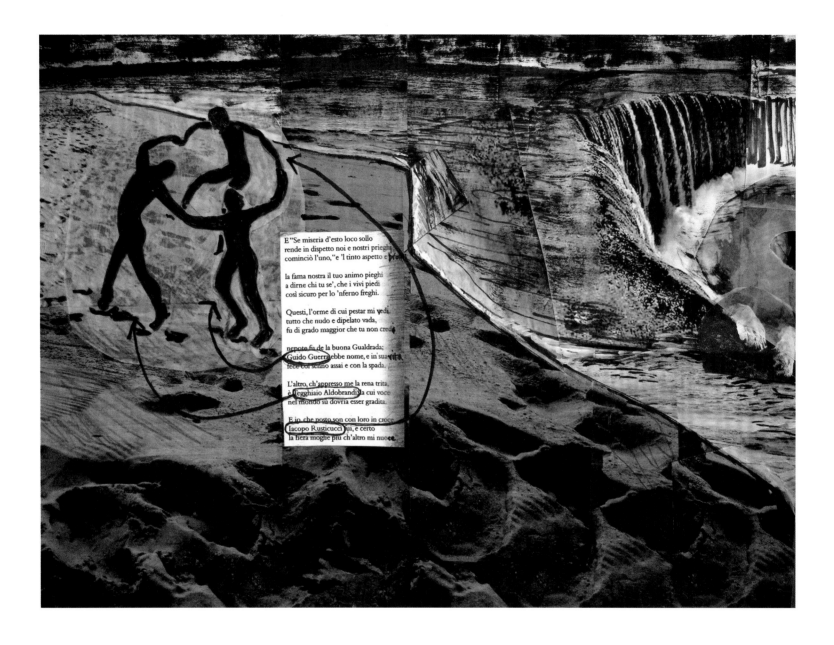

E "Se miseria d'esto loco sollo
rende in dispetto noi e nostri prieghi,
cominciò l'uno, "e 'l tinto aspetto e brollo

la fama nostra il tuo animo pieghi
a dirne chi tu se', che i vivi piedi
così sicuro per lo 'nferno freghi.

Questi, l'orme di cui pestar mi vedi,
tutto che nudo e dipelato vada,
fu di grado maggior che tu non credi:

nepote fu de la buona Gualdrada;
Guido Guerra ebbe nome, e in sua vita
fece col senno assai e con la spada.

L'altro, ch'appresso me la rena trita,
è Tegghiaio Aldobrandi, la cui voce
nel mondo sù dovria esser gradita.

E io, che posto son con loro in croce,
Iacopo Rusticucci fui, e certo
la fiera moglie più ch'altro mi nuoce.

XVI

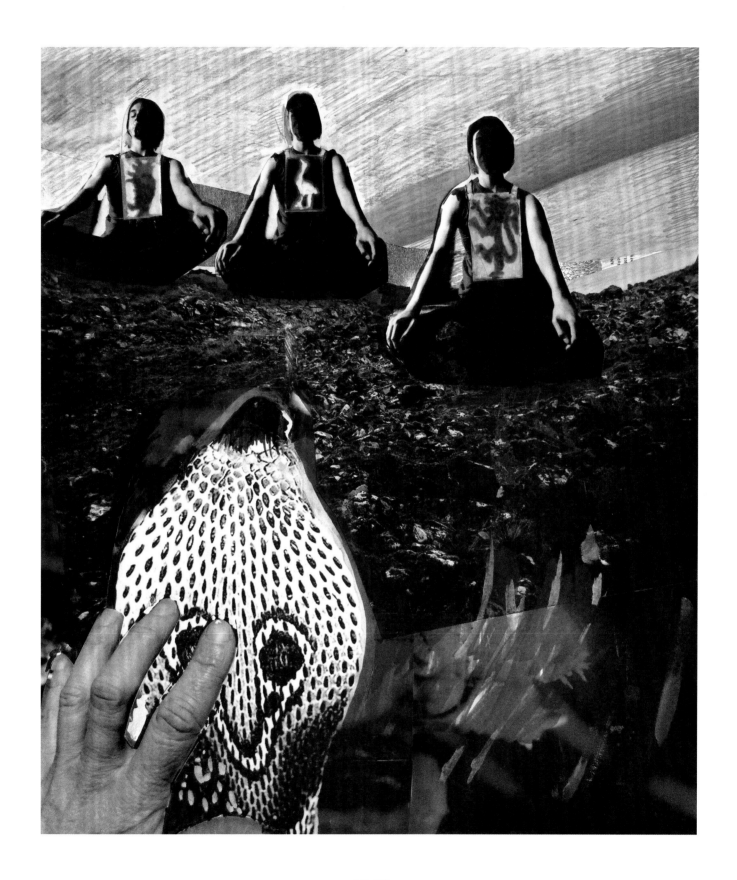

XVII

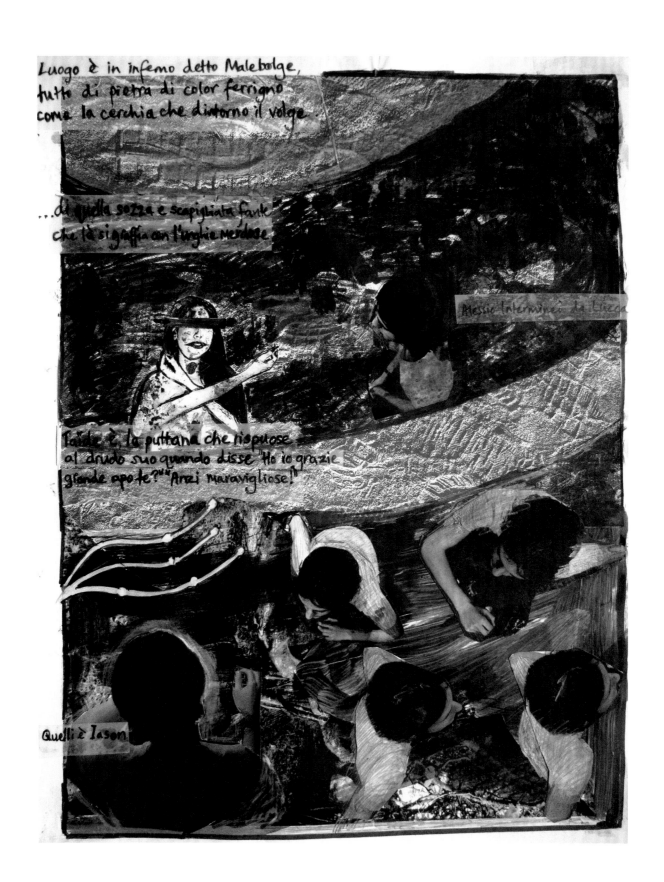

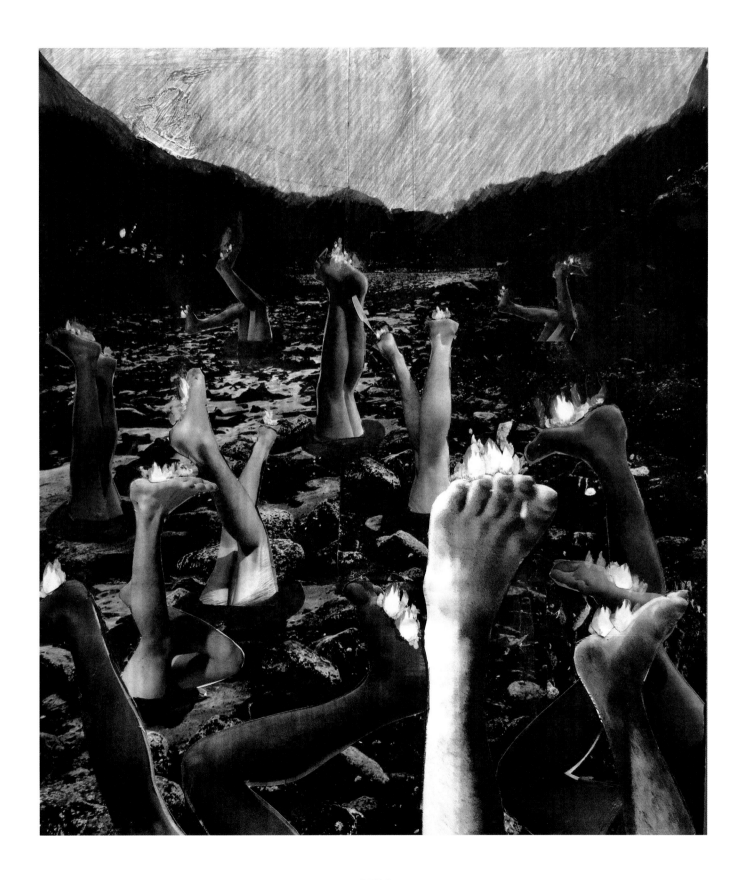

XIX

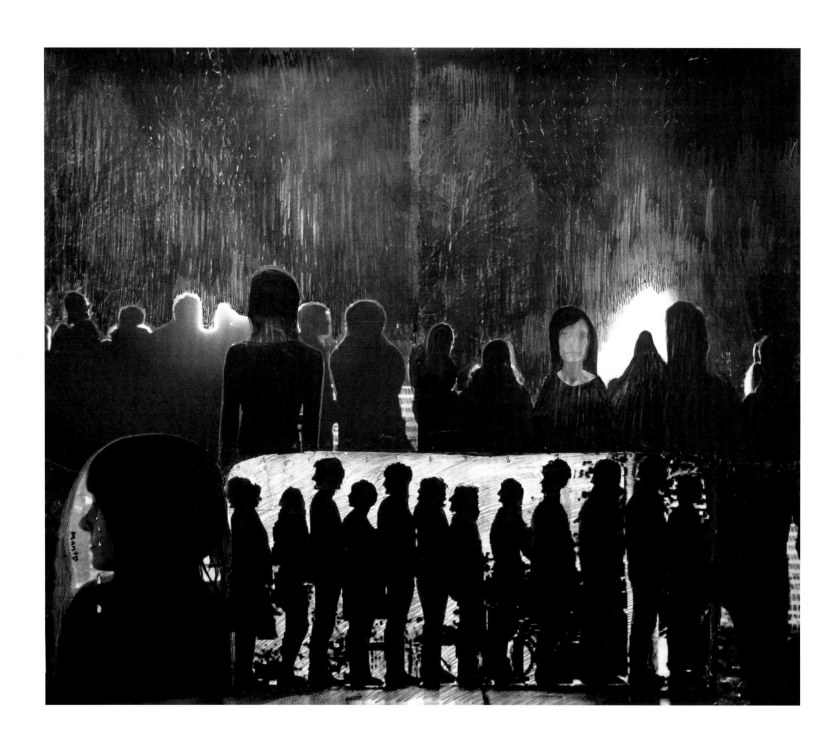

XX

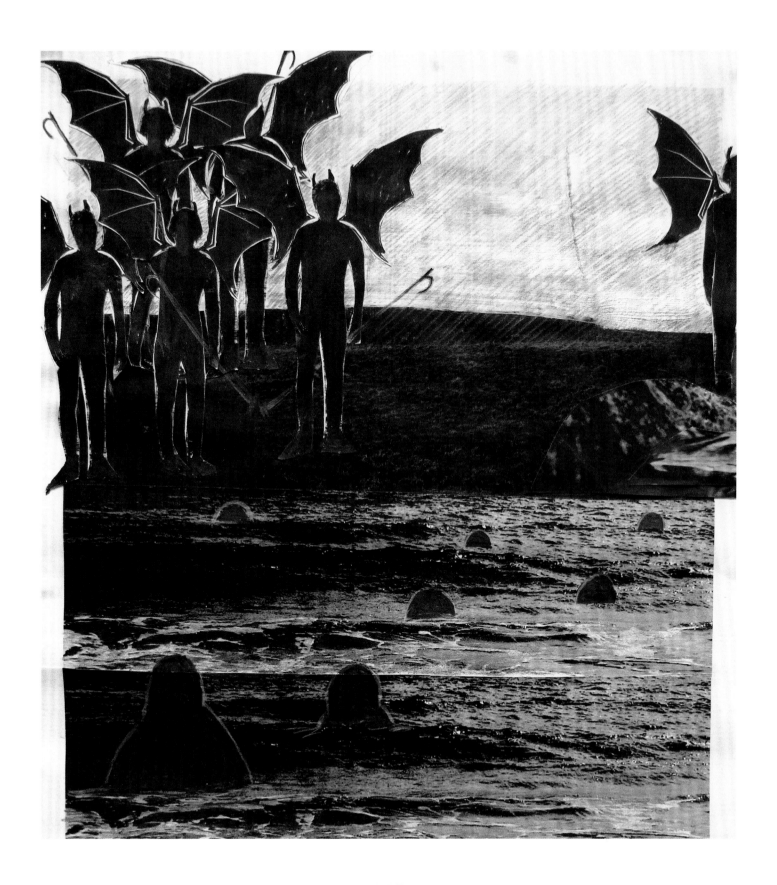

XXI

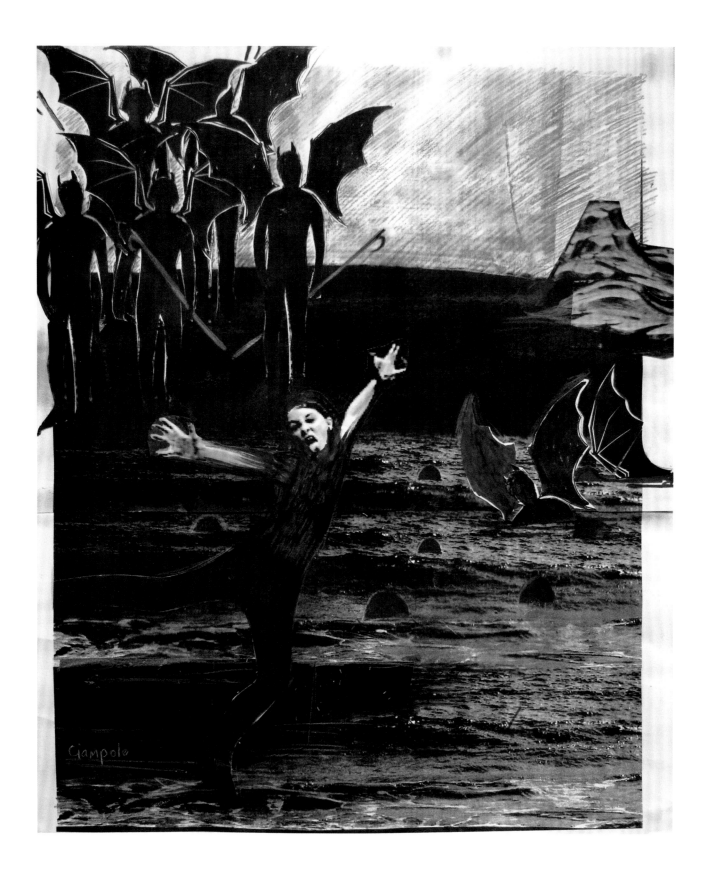

XXII

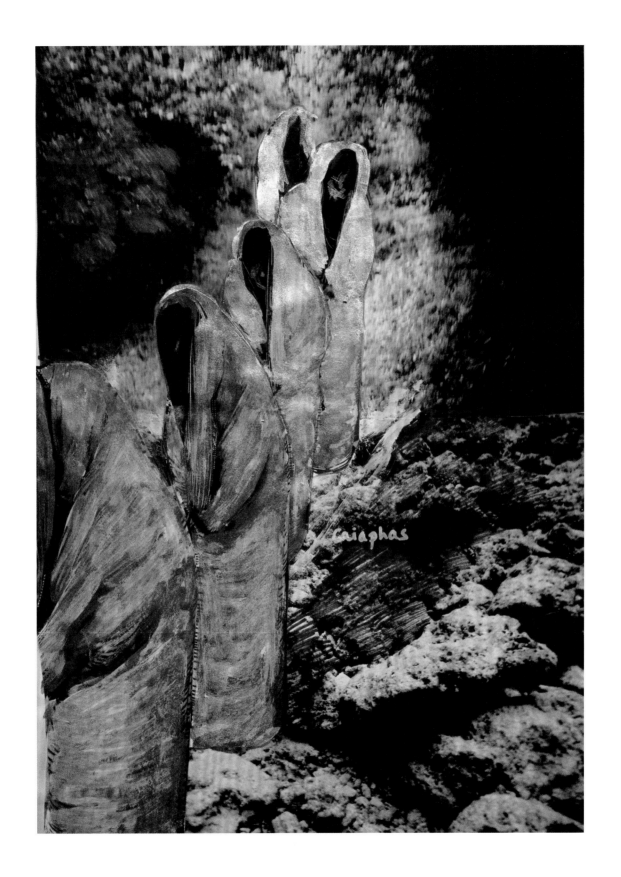

XXIII

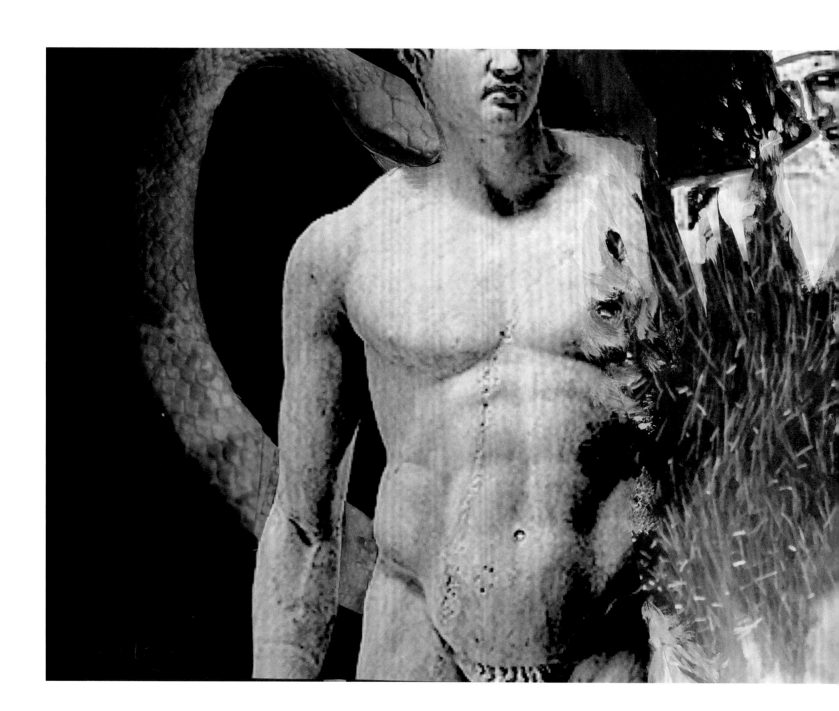

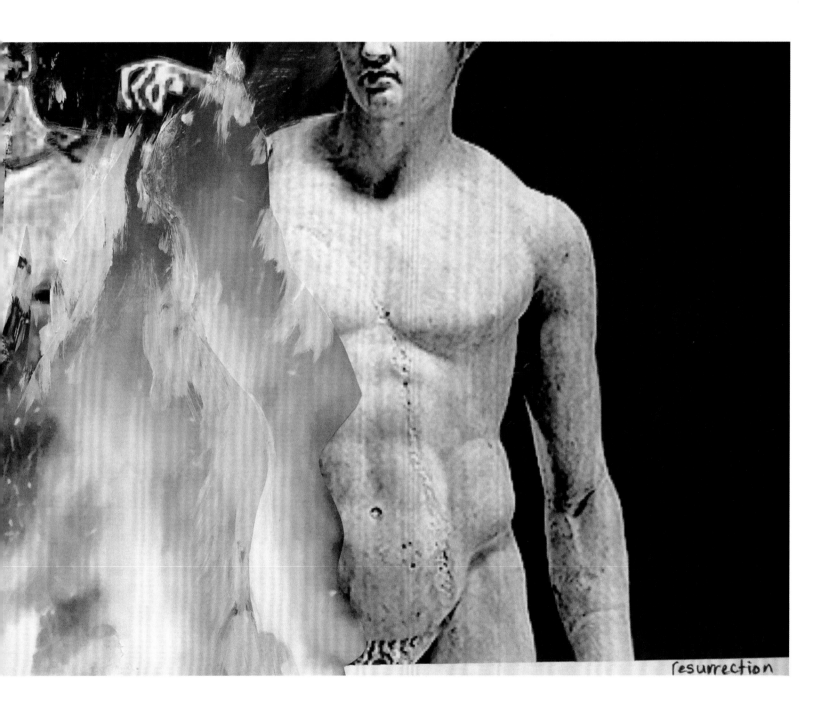

resurrection

XXIV

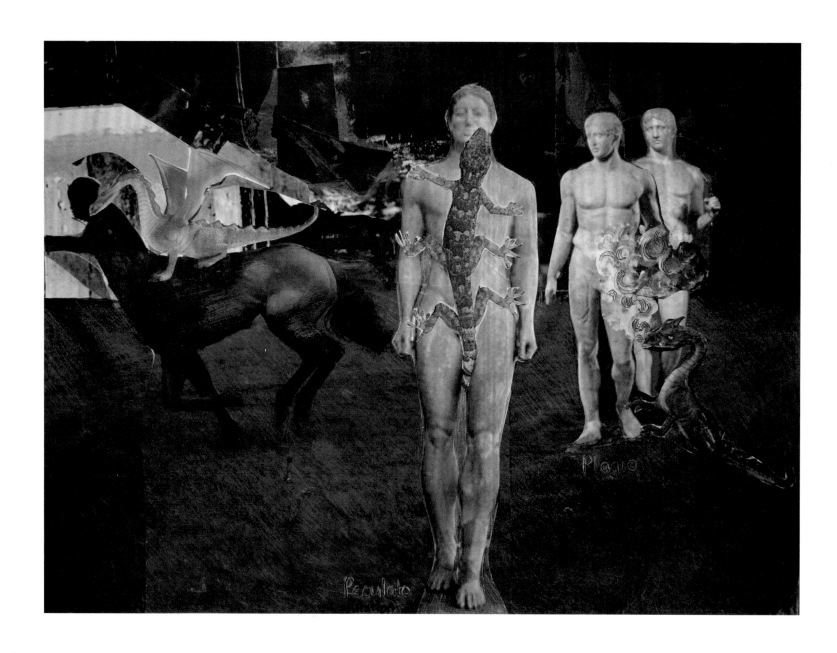

XXV

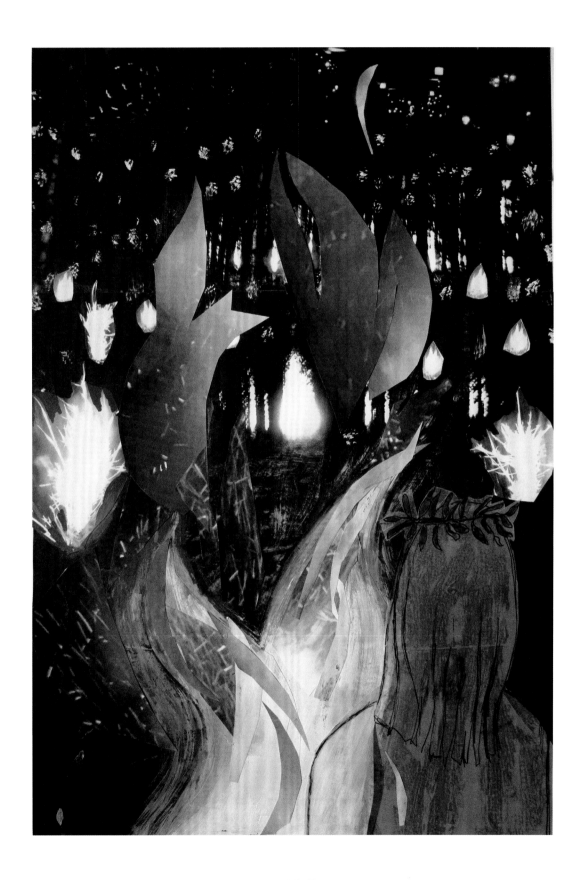

XXVI

Mentre ch'io forma fui d'ossa e di polpe
che la madre mi diè, l'opere mie
non furon leonine, ma di volpe.

Li accorgimenti e le coperte vie
io seppi tutte, e sì menai lor arte,
ch'al fine de la terra il suono uscie.

XXVII

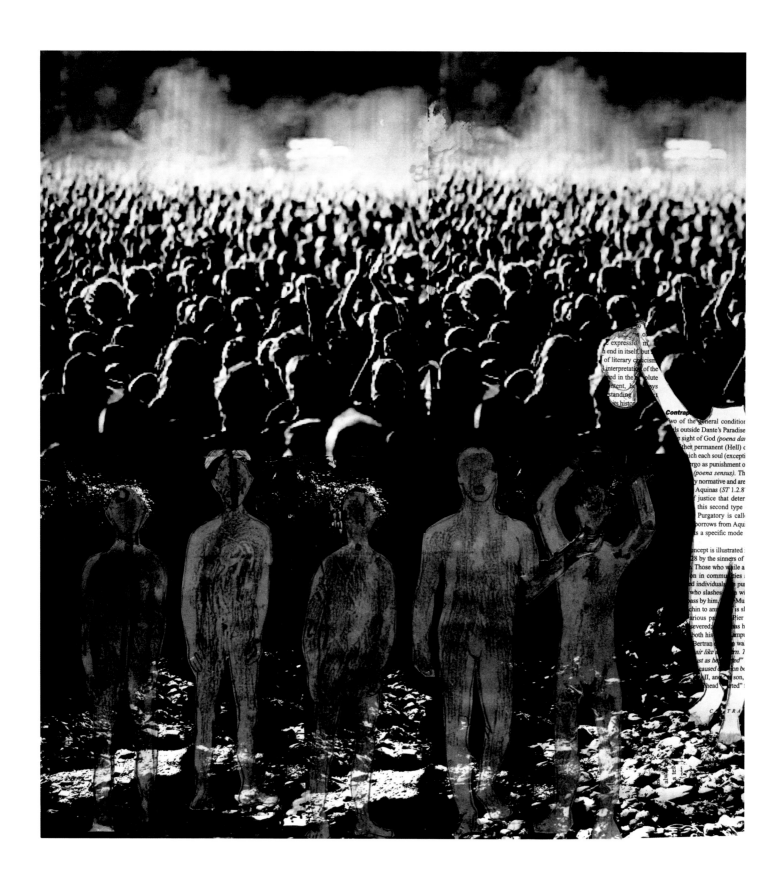

XXVIII

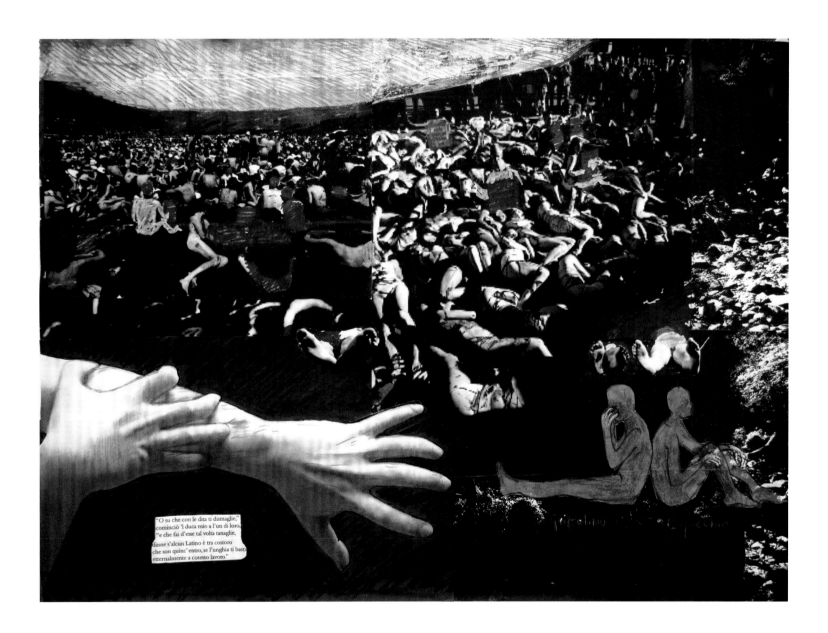

"O tu che con le dita ti dismaglie,"
cominciò 'l duca mio a l'un di loro,
"e che fai d'esse tal volta tanaglie,

dinne s'alcun Latino è tra costoro
che son quinc' entro, se l'unghia ti basti
etternalmente a cotesto lavoro."

XXIX

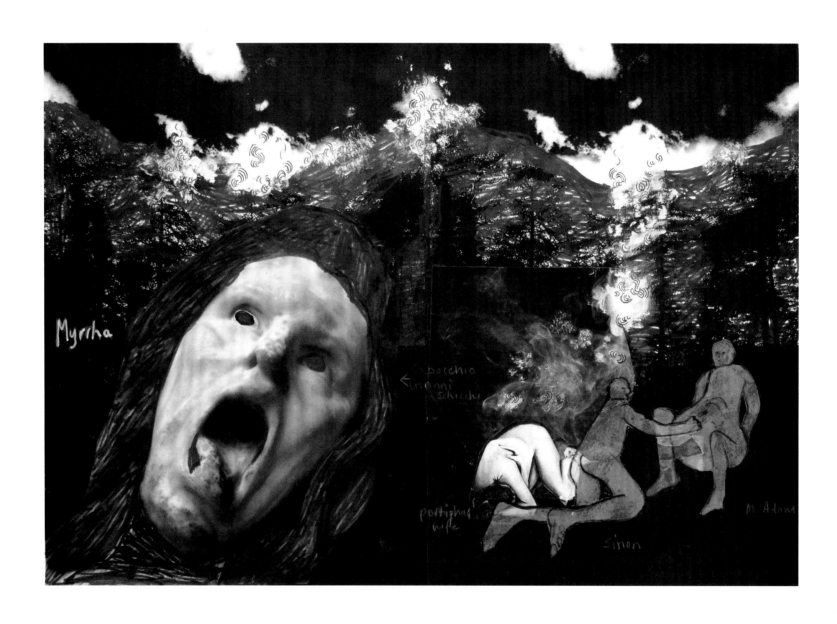

XXX

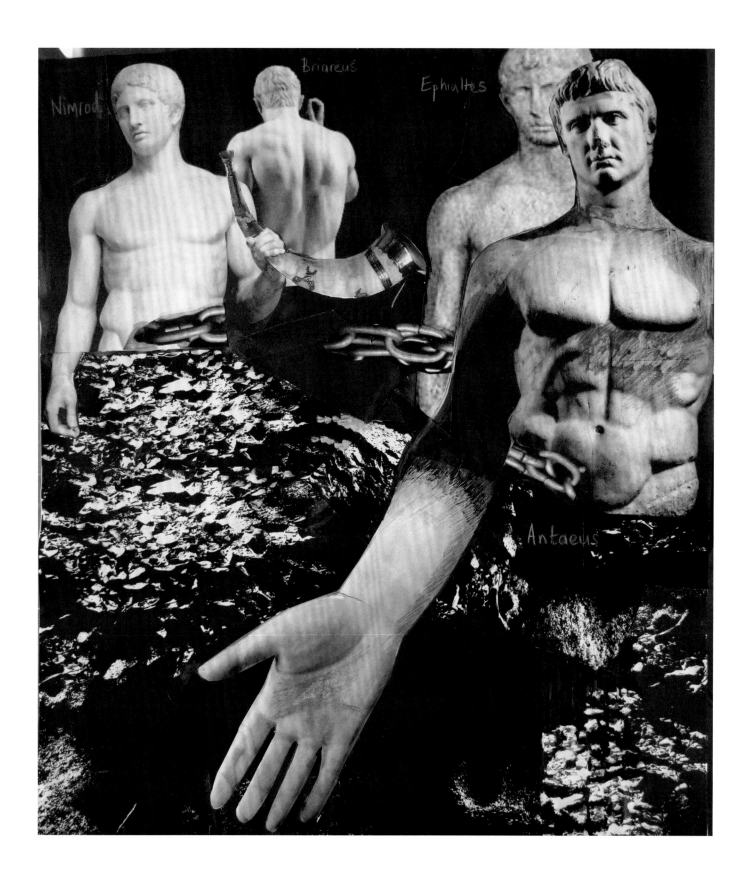

XXXI

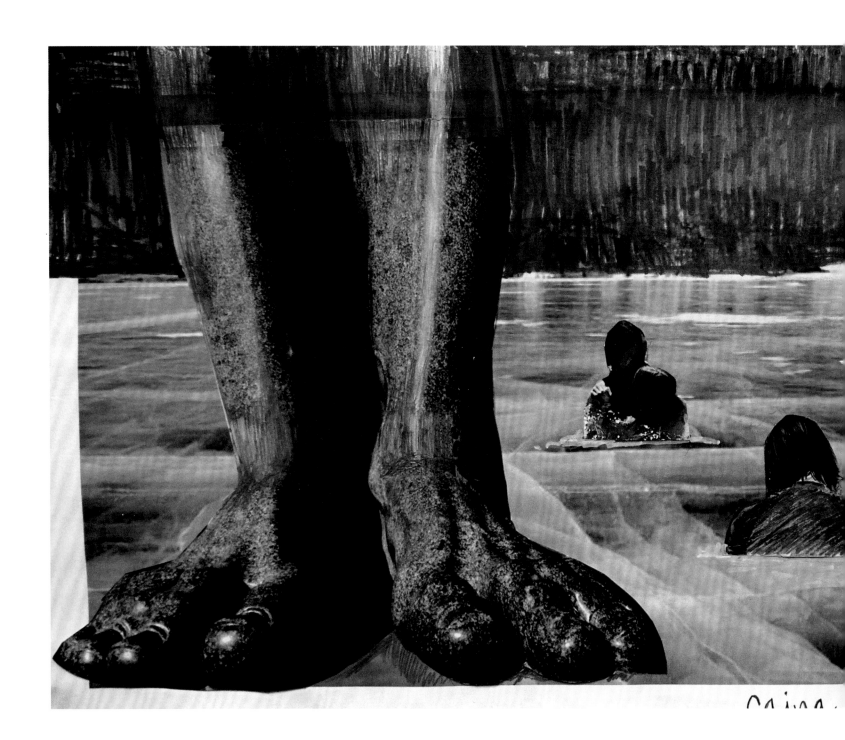

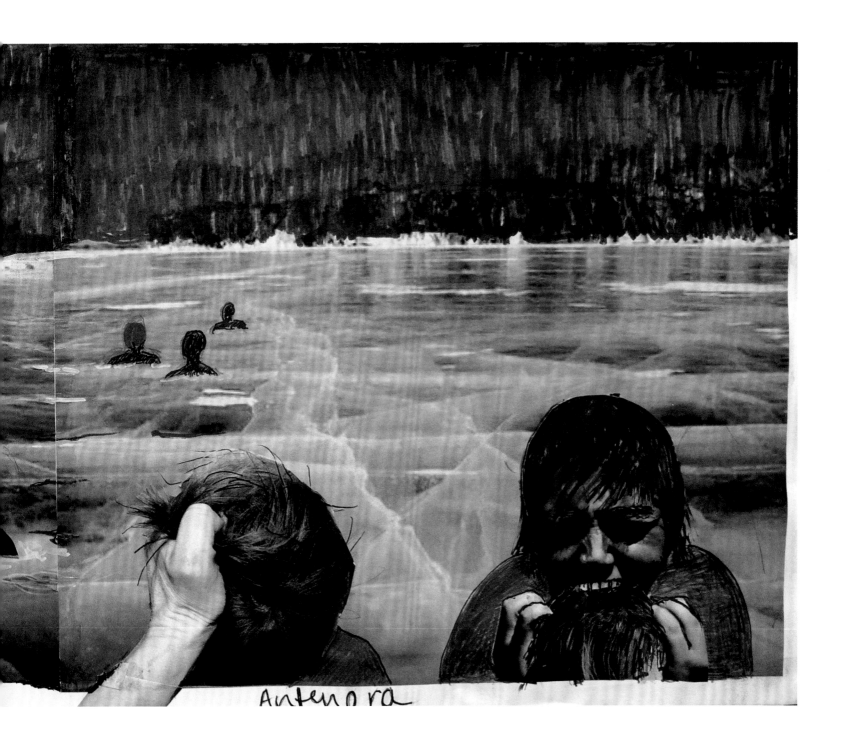

Antenora

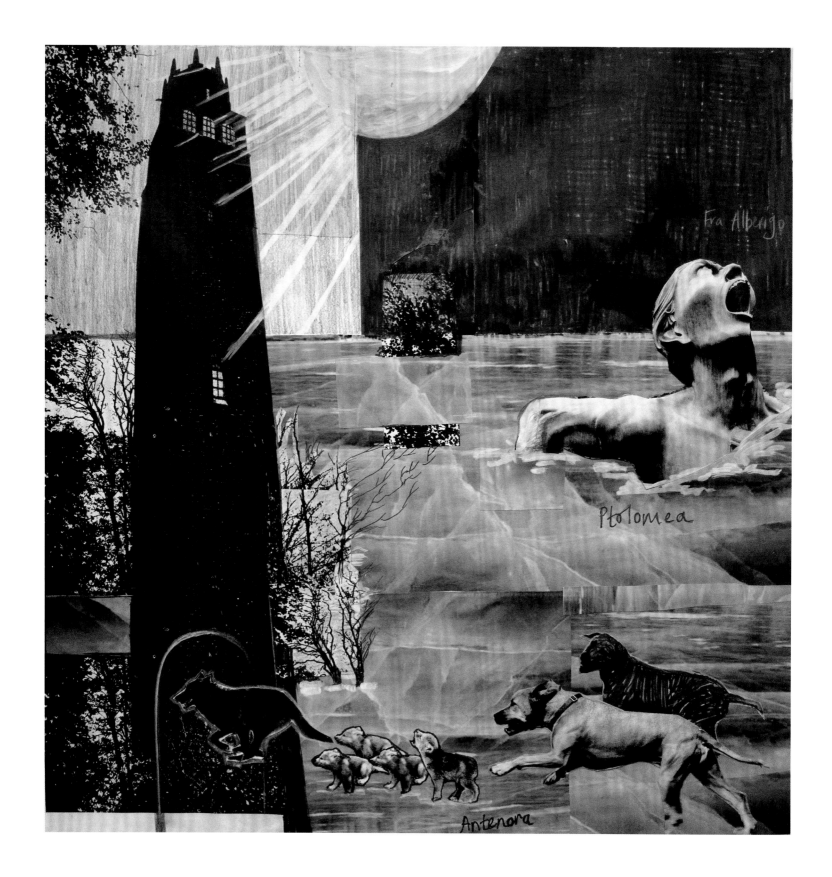

XXXIII

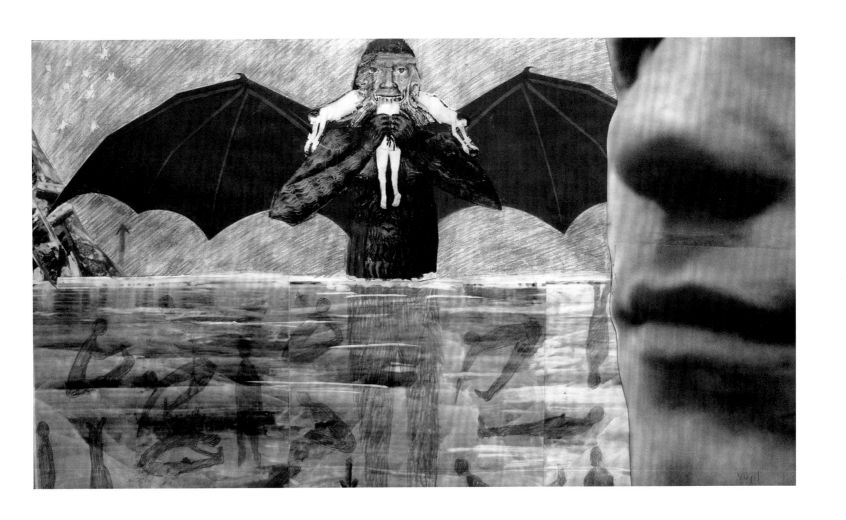

XXXIV

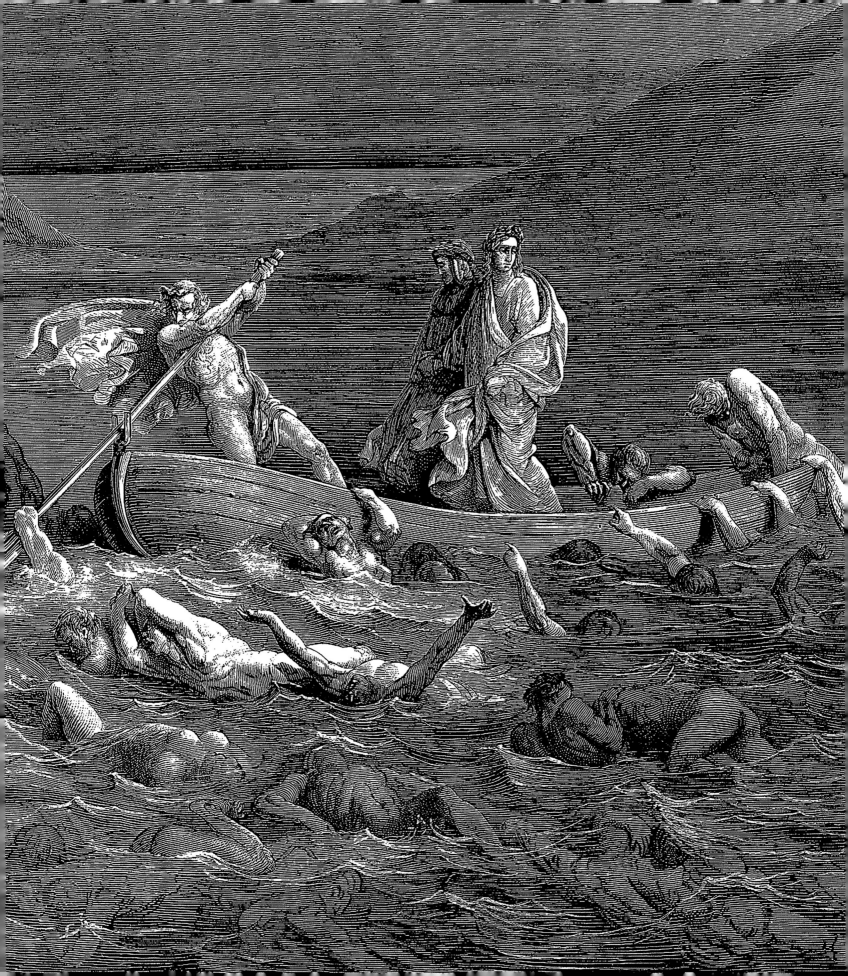

Fiona Whitehouse

When Rachel asked me, many years ago, which character from the *Commedia* I most wanted to be, I said Francesca. We were both twenty and had not long moved to Florence to study fine art on our year abroad. Strikes and absent tutors at the Accademia meant we had time to enrol in a class elsewhere to study Dante's poem. We bought a shared copy of the text illustrated by the nineteenth-century French artist Gustave Doré (1832–1883), whose engravings, characterized by an eclectic mix of muscular bodies and sublime landscapes, gave us our first glimpse of Dante's great visionary journey through the afterlife. By the end of the year, I had read only the *Inferno*. I was enthralled by Francesca da Rimini, trapped in an eternal whirlwind with Paolo, her adulterous lover, among the lustful sinners described in canto v. Her memories are so powerful Dante faints out of pity for her plight, as she tells her tale of falling in love with her brother-in-law. Rachel, already far more knowledgeable about the text and racing ahead of me, chose La Pia for her alter ego, a more taciturn character who appears in *Purgatorio*, who simply asks Dante to remember her among the living.

Rachel's interest in the *Commedia* lasted much longer than mine. By the time her first child was born, she had completed significant research on the subject, whereas I had long forgotten the details. Written in the vernacular rather than Latin, Dante's poem was accessible to a greater than usual proportion of the population, its popularity evident from the number of surviving fifteenth- and sixteenth-century printed editions and from the many earlier manuscripts in which artists illustrated the *Commedia*, both fully and in part. Rachel's research focused on the illustrated manuscripts that survive from the period between Dante's death in 1321 and the late 1490s, and she completed a PhD on this subject at Royal Holloway.[1] She worked on lesser-known examples, as well as the more celebrated artefacts, including the Bodleian Library's Holkham manuscript,[2] to explain how the illustrations reflect the rich content of Dante's poem, and tell much about his reception by early readers and artists.

Rachel's early artwork was influenced by the *Commedia* and long before she even completed her doctorate, she had printed at least three series of images closely tied to the text. For one, she used lithographic plates to depict characters from the poem

Inferno VIII: *Crossing the Styx*, Gustave Doré, 1861 (engraving on paper).

(including La Pia in *Purgatorio* v); in another she screen-printed medieval suns, stars and planets. In each series, she used collage to add extracts from Dante's text. Rachel developed the idea of depicting the entire *Commedia* around this time, but she didn't start her illustrations until 2012. By the time she died in 2016 she had completed the images for the *Inferno* and, as I discovered while writing this chapter, six cantos of the *Purgatorio*.

Rachel's *Inferno* illustrations demonstrate her profound understanding of Dante's *Commedia*. They are by turns ethereal, dark, consuming, apocalyptic, poignant, raw and beautiful. They are also original, and represent a deeply personal vision of the *Inferno*, making use of images of herself, her children and friends. It is this personal element that prompts the tricky question of whether we can properly judge Rachel's *Inferno* series without taking on board the circumstances of her then recent separation and her cancer. Does it affect the way we see her work? Perhaps it does, as her visual interpretations brought Dante's narrative to her own immediate present and past.

Her images are radically different from other illustrations of the *Inferno* for a number of reasons.

Her use of familial images places her domestic life firmly in the text that was so familiar to her. She positions the viewer as the pilgrim, clearly observing the scenes from Dante's perspective – we get a glimpse of 'our' robes in canto XV and 'our' hand in canto XXXII (see pp. 86–7). There is also the question of Virgil, Dante's companion throughout the *Inferno*, whom she characterizes as a shadowy female figure. I suspect it is meant to be a self-portrait, which would place her, as the artist, guiding the viewer as pilgrim. Together, these elements create something unique, while still in active dialogue with a long tradition.

These thirty-four visually textured photographic prints derive from collages crafted using a wide range of mixed media. Rachel cut up and glued photographs, tore photocopies and tracing paper. To these collages she applied acrylic paint, black felt-tip pen, black ball-point pen, white corrector pen, white corrector fluid, white chalk, gold and silver paint, coloured pencils and pens. Extensive passages are coloured with pencils pressed deep into the paper and many of the images include written and collaged text.

The original collages, which were photographed and printed to create the final unified collection,

la sinistra aucer era tal quali
uengon dila oued nulo saualla.
Doeto aascuna uscuam due grandili
quanto sicouenina adtanto ucello
uele dunar non uidio ma cotali.
Nonauian penne ma duuspirtello
era lor modo e quelle collaggeua
siche tre uenti simouean dacllo.
Quindi choato tucto sagelaua
p sei occhi piangeat e ptremeuti
gocciaual pianto e sanguinosa baua.
D aqtu bocca durompea codenti
un peccator agiusa dimaciulla
si che tre ne facea cosi dolenti.
A quel dinancy morder era nulla
uersol graffia che tal uolta laschena
rimanea della pelle tucta brulla.
Q uellanima lassu cha maggioz pena
dissel maestro e giuda scarricto
che dentro hol capo e fuoz legambe mena
Degliatri du chanol capo disocto
quel che pende dal nero ceffo e beu to
uedi come sisborce e no fa motto.
Et laltro e cassio che par si membruto
ma lanocte risurge e ora mai
e da partir che tucto auen ueduto.

lucifero coma lauea lasciato
et urdul lilegambe insu tenete.
Et sio diuenni alloza trauagliato
lagente grossalpensi che non uede
qualeral punto cho auea lasciato.
Leuati su dissel maestro impiede
lauia elunga el camin emaluagio
et gia il sole ameco tirza riede.
Non era caminata dipalagio
laue eauiam manatural burella
cauea mal suolo e dilume disagio.
Quana cho dello abisso midiuella
maestro mio dissio quando fu ducto
adtrarmierrorre un poco mifauella.
Due lagbraccia e questi come fiero
ti socto sopra e come uisi poco bza
rasern ad man ha facto ilsol eriggeto.
Et elli ame tu yma giri ancoza
tesser dila dilcentro du mi presi
alpel teluecino neo cielmondo foza.
Dila fosti cotinto quanto feesi
quando mi uolsi tu passasti punto
alqual sitraggon ogna parte ypesi.
Et se loz socto lemisperio giunto
che e opusto che lagium secca
conerbra e foctol cui colmo consisuto.

Lucifero.

cassio.

...sipuniscono glitrad...
ton. echiamasi giu
decha.

were never meant to be seen, and indeed Rachel had expressly asked that they not form part of the exhibited material. However, the unique way they were created reveals how she developed and assembled her narrative. Understanding how these preparatory works were made illuminates the author's aesthetic and technical concerns, and the material aspects of Rachel's *Inferno* prints are vital to their meaning as she interweaves Dante's literary and visionary landscape with her personal world.

The collages are generally larger than the final prints. By reducing them to produce the illustrations, Rachel condensed the design and ensured that the colouring would be more intense. The process also made the illustrations more consistent in size. Indeed, the measurements of the collages themselves vary enormously depending on the size and number of sheets of paper used. The process also reduced some of the material depth of the collages, thus providing a more uniform finish. Still, the materiality of the works is not lost to the viewer; the ripped and cut paper seams, pen and pencil marks remain visible, as well as the highly textured passages, ensuring that the sometimes brutal energy of the collages is still felt.

With the exception of the illustrations for the gates of hell (canto III) and the wood of the suicides (canto XIII), which are each constructed from a single sheet of paper, the collages consist of multiple pieces of standard white photocopy paper onto which black and white, or black, white and blue images were copied. Many of these images, which form the backdrop to the main narrative components, comprise highly textured stretches of ground or water. Each piece is cut to the required size and glued alongside another, slightly superimposed. Passages of paint, pencil and pen and irregularly cut images, photographs and text are added to create elements specific to each canto, so that the viewer can navigate the illustrations with ease.

The majority of the illustrations are in black and white. Overall, they are dominated by a dark tone, reflecting the inhospitable nature of the landscape. Nonetheless, some limited colour appears in numerous cantos. Light washes of acrylic paint and coloured water-based pencils are used in some of the illustrations. Colour is applied widely in canto XIV, for example, in which those guilty of violence towards God run on barren sand and we see the rain of flames

coloured with white paint and orange pencil. In canto xv, in which Dante meets his 'maestro' Brunetto Latini, Brunetto's hands are seen grasping the pilgrim's blue cloak, painted with an acrylic wash, and are vigorously coloured in brown and black felt-tip pen to amplify the sense of agitation and movement in this illustration. A red wash is also applied lightly to the foreground of canto xvi to indicate the burning sand.

In other cantos, colour is used in smaller areas and with greater focus to highlight key elements. Virgil's green headdress is always coloured with a felt-tip pen. A yellow cut-out flower, representing Dante's renewed purpose in canto ii, is also coloured in felt-tip pen. Colour is used for the flames and beasts in later cantos and these are usually cut-out colour pictures, like the turquoise-and-yellow dragon tormenting the thieving centaur Cacus in canto xxv and the bright flames of the false counsellors' souls in canto xxvi. In the same illustration, the double flame containing the souls of Ulysses and Diomedes is made from multiple colour collages onto which the artist applied yellow and orange paint and pencil.

Colour is also employed to highlight some of the more gruesome aspects of particular *bolge* (the ditches that serve as subsections of the eighth circle of Dante's hell, the Malebolge, where the fraudulent are punished). In canto xxviii, specks of red paint are applied to the foreground figures to demonstrate how they are slashed by the devil's sword according to their sin; in canto xxix the leprous bodies of forgers and falsifiers are marked with red pen and pencil to indicate where they have flayed their bodies with their nails.

Gold and silver appear in just two cantos, to illustrate moments when these two colours are central to Dante's imagery. The figure of the Old Man of Crete in canto xiv is coloured with gold and silver pen and orange pencil, while gold is used more extensively in canto xxiii, where the hypocrites are weighed down with gold-covered, leaden capes. Each cape is treated to passages of gold and white paint, creating an eerie contrast to the pale grey light from which they emerge.

Overall though, the illustrations are dominated by the black and white of the base images, to which the artist has applied acrylic paint, chalk, corrector fluid, pencil, biro and felt-tip pen. Black and white are used to define figures, create shadows, add highlights and decorative effects, write text, draw narrative elements

or fill in stretches of landscape. In some illustrations, the application of the additional media is particularly vigorous. For example, in canto XII, in which the centaurs guard Phlegethon (the river of blood where the souls of the violent are punished), the illustration is thick with paint and other marks. Acrylic paint in a pale tone is applied to the sky, onto a section of which the artist has added white corrector fluid, now cracked and flaky. Ball-point pen covers parts of the middle ground while black felt tip marks the foreground. Black acrylic paint and felt tip have been applied to the centaurs, so forcefully in places that they have damaged the paper.

To steer the viewer through the series, Rachel included within the illustrations a mixture of lines from the poem and character labels. These are added, for the most part, with a fine Pilot graphic pen, but also in felt tip, pencil and white pen, and often on tracing paper which is then glued to the background. One of the more arresting examples is the illustration to canto III, where text takes centre stage. Across the gates of hell, decorated with images of sandy footprints to symbolize the innumerable dead souls, we find text written with black pen on tracing paper;

above the gates we see the address 'you who enter' marked in white pen alongside other text in white pencil. As in Dante's poem, the script here serves as an architectural inscription.

The arrangement of the figures is another of the intriguing ways the artist guides the viewer through the narrative. Although Dante the pilgrim is never fully depicted in Rachel's *Inferno*, as mentioned above, Virgil is visible in a number of cantos and is always represented with a line drawing on tracing paper. The cut-out translucent Virgil is then glued to the background, creating the shadowy illusion of a person. Other figures are also drawn onto tracing paper, such as the three sodomites, their dancing forms based on Matisse's *The Dance*, who appear in canto XVI. These dancers, representing three famous Florentine Guelph leaders of an earlier generation,[3] are coloured in black felt pen on tracing paper, cut out and applied to the background. The sowers of discord depicted in canto XXVIII are also drawn on, and cut out of, tracing paper applied to a blueish sea of sinners, taken from a photo at a music festival, possibly Glastonbury. Other figures are cut from *Dante Encyclopedia* entries (see pp. 74–5 and p. 95).

For other damned souls, Rachel uses photographic images of stone and marble statues. In canto VI, for example, the Florentine Ciacco, whom Dante addresses to ask about the state of Florence, is depicted as a limbless statue. In canto XXX, the head of Myrrha, who tricked her father into sleeping with her, is constructed out of a photographic image of a statue's head, grotesquely contorted with blackened eyes, a twisted tongue and a thick mane of hair drawn in black felt-tip pen. Other prominent characters are represented by statues in cantos XXIV, which sees the thief Vanni Fucci consumed by fire and then restored to human shape, and in canto XXV, where the figures of thieves transform into reptiles. In canto XXXI, the giants are more cut-out pictures of ancient statues, while Antaeus' hand, stretched out to lift Virgil and Dante to the bottom circle of hell, is a photographic image of an actual human hand.

In other cantos (XXVIII and XXIX, for example), more generic images of people depict the souls in hell.

In a number of the illustrations, the characters are clearly recognizable as Rachel's friends and family. A photograph of her estranged husband, for example, to which she added the feet of a lion, appears within the waterfall of canto XVI, and my own profile is used to depict Francesca carried along by the dark wind in canto V (fulfilling my own destiny imagined years previously). It is her children, though, who take centre stage. The heretics in canto X are represented by a single figure of Rachel's son, and each of the usurers in canto XVII is based on images of his distinctive frame. He appears six times in canto XVIII, a depiction of seducers and pimps plunged into excrement. Rachel also uses his outline in canto XXI, where he merges into the company of devils. The artist's daughter makes a particularly dramatic appearance in canto XXII as the audacious escapee who teases the viewer by diving in to photo-bomb the scene. In canto XXXII, among the frozen souls, there is a beautiful cut-out image of Rachel holding her daughter in a pool, from a photograph taken less than two years before she died. Rachel's daughter makes one final appearance in the recently found unfinished *Purgatorio* illustrations, where she is depicted as La Pia in the image for canto V. This last discovery is important because it suggests that her use of family and friends as accessible photographic material was not only intended for the *Inferno* but for the entire series, had she been able to complete it.

It is the use of self-portraits, however, that makes Rachel's *Inferno* particularly personal. In some cantos she has undoubtedly used images of her own shadow and outline. In canto iv, for example, which illustrates Limbo, where the souls of the virtuous pagans and the unbaptized reside, cut-outs of her own shadow have been applied against a highly textured architectural landscape, representing the 'noble castle' of Limbo (*Inferno* iv, 106). She also uses her outline to depict the false prophets whose heads are back-to-front in canto xx. A more direct representation can be seen in canto ii where she appears perhaps as the saintly Beatrice who, the poem tells us, is concerned about Dante's welfare. Here, Rachel is looking directly at the viewer. Using an over-exposed image, she has created a self-portrait that is both open and spiritual. The most touching self-portrait, though, is saved for canto xx, where she used a photograph of herself, taken when her daughter was just a toddler – I found the original photograph on her desk – to depict herself as Manto, whose city Mantua was founded after her death by the community that rejected her. We see Rachel's profile with tears falling down her face. Both self-portraits are difficult to look at,

reflecting as they do her own painful, inconvenient and infuriating situation.

A close examination of the collages illuminates how the artist chose the perfect media to create a series of illustrations that are restless, expressive and direct. The constant stop-starting of cut and torn images, overlapping with passages of other photographs, photocopies, pen, pencil, paint and tracing paper, challenges the viewer to look closely at the eternal uncomfortable truths of the *Inferno*. Her visual reimagining of the poem reminds us of the personal nature of Dante's work, but while her prints depict the relentless grief and suffering of the souls in the *Inferno*, it is her use of personal images which demonstrates how comfortable she was with the text as a whole. She was creating a vision of Dante's landscape that was meaningful in a deeply personal way and by doing so she put a human and contemporary face to his work, bringing home to the viewer the raw humanity of the poem as a whole.

Detail from *Inferno* V: Francesca among the carnal sinners, Rachel Owen, 2016 (photographic print of mixed media collage).

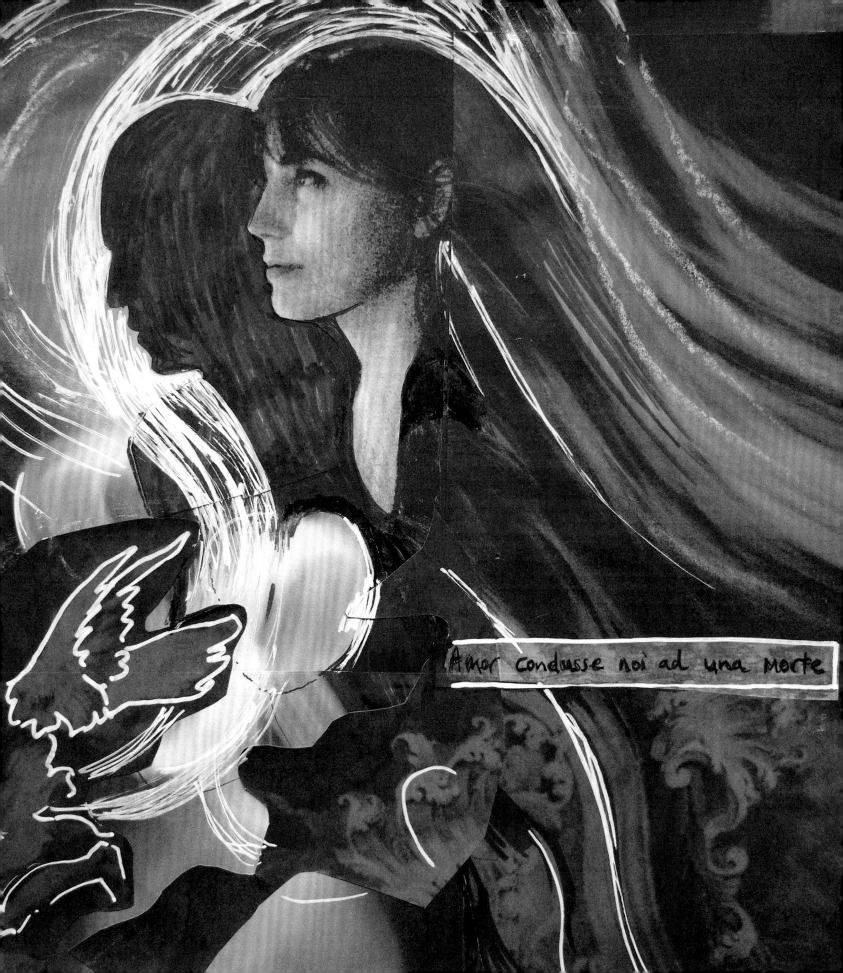

Amor condusse noi ad una morte

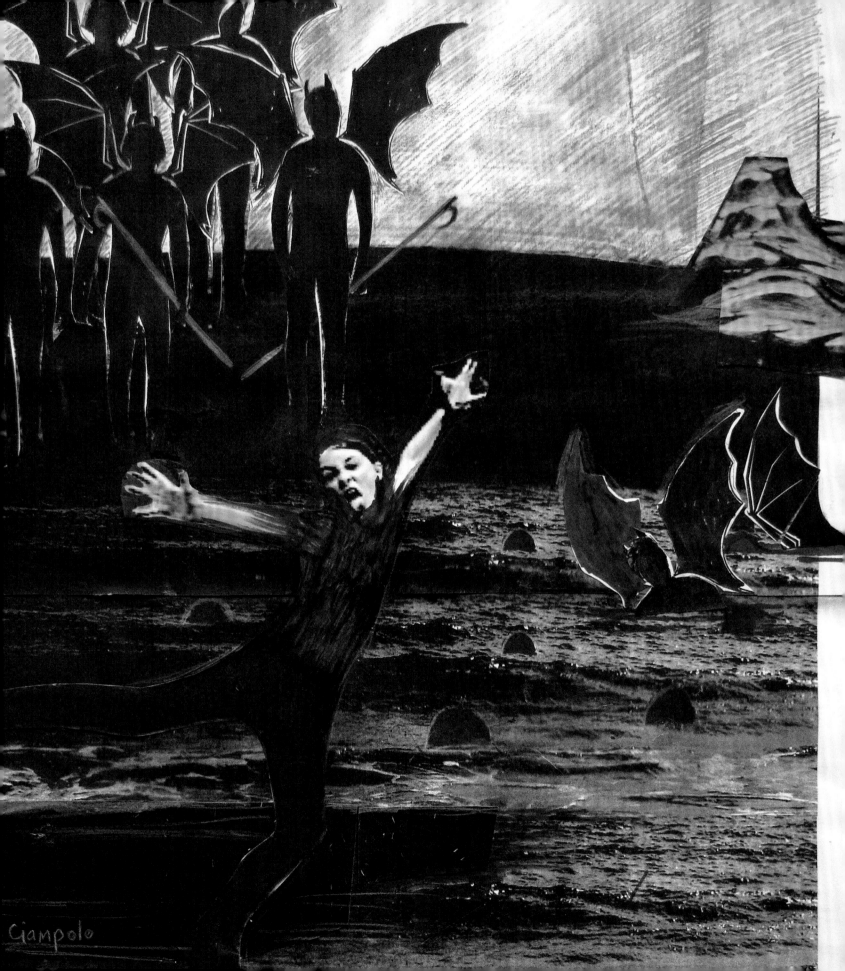

An Original Vision

Peter Hainsworth

Rachel Owen strikes a very unusual figure as a Dante illustrator. She was an art historian whose research interests included the history of Dante illustration, especially in fourteenth- and fifteenth-century manuscripts. She was also a teacher of literature, again with Dante as her primary interest. The majority of other artists who have chosen to illustrate Dante have been primarily, even exclusively that – visual artists who would not pretend to be writers or scholars in their own right. One of the few exceptions is William Blake (1757–1827), a poet if not a scholar, but again someone obviously unlike Rachel in being a man. Almost all Dante illustrators, of whatever epoch, have been male, with very few exceptions. Among women artists working in the UK, the only instances I know of are Phoebe Anna Traquair (1852–1936) in the nineteenth century and Monika Beisner in the twenty-first. Rachel's illustrations have, then, a remarkable personal and scholarly hinterland, and one that has significant purchase on the nature of the work she produced.

First of all, it is worth noting that sequences of Dante illustrations that follow the text canto by canto are by no means numerous, certainly in comparison with the vast number of translations of the text itself. Well over 150 translations of either the complete *Commedia* or of just one of its three parts (*cantiche*) have appeared in English since Henry Boyd (1750–1832) published the first complete version at the remarkably late date of 1802. In contrast, though there have been a considerable number of illustrations of individual episodes, few artists of note have completed a full set of illustrations to one *cantica*, let alone to the whole *Commedia*. Botticelli (c.1445–1510) is the most famous. As far as an international reader of Dante, and certainly a British or American one, is concerned, the best known is Gustave Doré, the French artist whose monochrome etchings appeared in almost all editions of the *Vision of Dante* by Henry Cary (1772–1844), which became the most read version of Dante's *Commedia* in the mid-nineteenth-century in anglophone contexts and remained so until at least the 1920s. Apart from Doré, the only other Dante illustrator well known in the nineteenth century was John Flaxman (1755–1826), though John Dickson Batten (1860–1932) completed a sadly neglected series to accompany his friend George Musgrave's 1893 translation of the *Inferno*, illustrations that were

Detail from *Inferno* XXII: Ciampolo escapes his demon-captors.

themselves eclipsed when that translation vanished from view.[1] There have been rather more series in recent times, in the twentieth century notably those by Robert Rauschenberg, Salvador Dalì and Renato Guttuso, while more recently Tom Phillips and Alasdair Gray have created illustrations to the *Inferno* which they have published together with their own translations of the text.[2] Monika Beisner is one of relatively few artists to have illustrated the whole *Commedia* canto by canto.[3] Leaving aside graphic novel and cartoon adaptations, numbers overall are not large. Rachel therefore joined a select company in embarking on her project, sadly cut short by her illness, but still leaving us with her forty completed images, covering the whole of the *Inferno* and the opening six cantos of *Purgatorio* (see pp. 107–25).

In some ways it is easy to see why the number of artists should be small. The *Commedia* consists of a hundred cantos, thirty-four cantos for *Inferno*, and thirty-three each for *Purgatorio* and *Paradiso*. To complete a set of illustrations for even one *cantica* is thus a major artistic undertaking, and one rendered all the more arduous for any artist who wishes to pay anything like close attention to the text by the density and richness of Dante's writing. He is known as a writer with a strongly visual imagination, and no doubt that visual aspect is one of the factors that have drawn artists to him, but there is always a great deal more going on. Artists, much more than literary commentators, have to select what elements they will concentrate on in any particular canto, how they will deal with the narrative pushing the text forwards, and then, if they should get beyond the *Inferno*, how they will deal with the philosophical and religious questions that come increasingly to the fore in *Purgatorio* and *Paradiso*. Perhaps that is one of the reasons why artists, like many readers, have tended to stop after the *Inferno*. Rachel was again unusual: her original project was to continue further, and she undoubtedly would have done so, if her life not been tragically cut short.

What, then, of the relationship between text and image? It was possible in the nineteenth century to see illustrations as providing visual images that could be 'read' unproblematically alongside the words of the text. Henry Longfellow (1807–82) wrote of Flaxman's illustrations that they constitute 'the work which I would urge every reader of Dante to have by him

Inferno XXXIV: Tom Phillips, 1983 (lithograph on paper).

go on; go on.

the heavens open
Look up; look up.

See the depth above us, and
endless space, and all
and a ball of
two eternities milky light
 —the book of
yet remains to be written. stars
 vibrating

as he reads'.[4] That sort of imagined relationship no longer seems possible. Standard modern reference and reading editions of Dante in whatever language do not normally contain illustrations, beyond a prefatory portrait of the poet and perhaps diagrams of the structures of the three regions of the afterlife. The editions containing the illustrations of Tom Phillips, Alasdair Gray and Monika Beisner are published in limited numbers, and, whatever the artist may be hoping for, are likely to have a limited number of readers. Mary Jo Bang's translation with illustrations by Henrik Drescher, made available in a paperback edition, provides a rare exception.[5] These artist editions however do set up an interestingly ambiguous relationship between text and image. The reader-spectator may treat the text as a back-up to be drawn on to elucidate events and images depicted, and more or less at the same time read the images against the text, evaluating and enjoying the particularity of this vision of Dante and making comparisons with the artist's practice elsewhere. The process becomes particularly complex in the case of Tom Phillips, whose translation of the text bears comparison with scholarly translations in terms of accuracy and readability.

As has been common practice since Botticelli, sets of illustrations have often been published separately from the text, with the inevitable consequence that the artwork tended to become more and more the dominant element. Dante's text comes to be seen as something providing inspiration, a starting point the reader of the image had still, probably uncomfortably, to take account of. The catalogue of the 2017 exhibition of Rauschenberg's illustrations at the Museum of Modern Art, New York, for instance, provides at its end summaries of each canto, of around 250 words, which undoubtedly provide the material for reading Rauschenberg against Dante.[6] Quite how much used they are in reality is, I think, a moot point.

Rachel too worked with and within this general practice. Her illustrations were created in the expectation that they would be exhibited independently. In the event a sentence or two on each canto was added in the notes accompanying their exhibition in Pembroke College in 2018. All the same, as we might expect from a scholar of Dante, Rachel's illustrations resist the full detachment of image and text. Indeed, they ask us to read them not just as powerful, highly personal images in their own right,

Inferno X: Dante encounters the Heretics, Monika Beisner, 2007 (tempera on paper).

but as highly aware, modern confrontations with Dante, which in many ways force us back to the text of the poem.

A comparison with Rauschenberg highlights Rachel's procedures. Rauschenberg, like Rachel, worked with collages of photographic images, in his case creating transfer drawings by a technique of dissolving a newspaper or magazine image in lighter fluid and transferring it by rubbing onto another sheet, then adding colour or monochrome shading. The end result contains blurry images of young men together with some modern artefacts and signs, but large areas of the image tend more towards abstraction, the pale shades that the transfer technique favours evoking both distance and uncertainty. The result is often only a generic or fragmentary connection with the original text, as in the illustration to canto XXVI, for example, which has Virgil and Dante (as elsewhere shown as a youth in white shorts) looking down onto what may or may not be a fiery pit, with no depiction of Ulysses though perhaps with references to his voyage emerging in the panel below. Rachel is at least as modern in her techniques, composing her collages from black-and-white photographs, going over images, particularly those of people, with additional black and white touches, and adding in elements of colour, sometimes

to highly dramatic effect. In this regard her version of Ulysses and Diomedes enveloped in tongues of flame contrasts strongly with Rauschenberg's image. In general, unlike Rauschenberg, Rachel sets her figures, all plainly and forcefully delineated, in what are recognizably landscapes, though often fragmented ones. Like the landscapes evoked by the actual text, they are real and unreal at the same time, not dreamy or nightmarish (as Doré's Gothic landscapes were) and not just pseudo-realistic representations of a clichéd, hellish modern world, as they might have been. Abstraction, in the sense of areas of the picture space that are not directly representational, may be present but to a limited degree and with strong overtones of movement and turmoil. Instead we encounter broken cities, groups of houses, seascapes or river scenes, and the frozen wastes of Dante's lowest circle of hell.

Unlike Rauschenberg and many other modern illustrators, Rachel pushes us firmly back towards Dante's text by introducing verbal elements of one kind or another. Characters' names are often spelt out in crude handwritten letters, sometimes with indicating arrows, as if a teacher is abruptly pointing out who it is to a pupil, a feature reminiscent of a

number of those medieval manuscript illustrations that formed the focus of Rachel's research, including the Bodleian's Holkham manuscript (see pp. 94–5). Italian names appear in the Italian form, classical ones in the form they normally have in English, for Rachel seems to presuppose an English-speaking viewer who has some minimal knowledge of Dante's text. Now and then she includes quotations of lines in Italian, generally famous ones – such as the inscription over the entrance to hell. Sometimes she makes remarkably effective use of scholarly explanations from the *Dante Encyclopedia*. A striking instance is her reduction of the figure of Bertran de Born (canto XXVIII) to an outline enclosing a definition of the concept of 'contrapasso', a term that appears in his speech for the first and only time in the *Inferno*. The word refers to the punishment replicating the crime and turning it back upon the perpetrator. Bertran created division between the king of England and his son: his punishment was to have his head (corresponding to the king) separated from his body (the prince). Rachel's representation of him with the printed text inside his body and the head he is holding accentuates the horror while literally defining the 'contrapasso' he suffers.[7] At the same

Inferno XXVI: Circle Eight, Bolgia 8, The Evil Counselors, from the series *Thirty-Four Illustrations for Dante's Inferno,* Robert Rauschenberg, 1959–60 (solvent transfer with watercolor, wash, and pencil on paper).

time this gloss points us to something of relevance for the punishments of hell in general, though not in a simple way: for this explanatory text is itself fragmentary, mutilated, requiring thoughtful reconstruction rather than passive receptivity if we are to grasp what is actually going on. Perhaps it too alludes to a lost whole.

There is often unusual visual engagement with details of the text. To take one particularly forceful example, canto XXXIII is celebrated for the story that Ugolino tells of himself and his sons being starved to death in the tower in Pisa in which they have been imprisoned by his enemy Archbishop Ruggieri. Rachel chooses not to represent that story as such, leaving out the figures of Ugolino and his sons entirely. Instead she makes the tower the dominant element, a black shape that rears up forbiddingly through dark, wintry-looking trees and occupies almost the whole length of the picture's left side. The story itself is also evoked by details: Ugolino tells of a dream in which a wolf and its cubs (himself and his sons) are hunted down and torn apart by ravenous hounds (his enemies). Rachel shows a black wolf and some particularly cuddly looking cubs (Ugolino dwells on

his sons' innocence) being chased by large hounds in the picture's right foreground. It is when dawn comes after this dream that Ugolino realizes the full horror of their situation and Rachel paints in the all too pallid rays of the sun streaming down to illuminate a few windows of the tower. The minimal degree of colour in this illustration is found in the bluish ice in which Ugolino is pinned, which occupies more than half the image and over which hangs a black sky. We are thus not in the world above at all but firmly in hell, and in the ninth circle, Ptolomea (the name is included in the image), where traitors to their guests are punished. Unusually for illustrators of the Ugolino episode, which occupies only the first two-thirds of the canto, Rachel then includes the next traitor that Dante meets, Fra Alberigo, again identified by name, who is shown raising his eyes desperately skywards. In the text he begs Dante to remove the ice with which his eyes are encrusted – a request to which Dante initially agrees but then goes back on his word, somewhat dismayingly for the soft-hearted modern reader.

There is no attempt by Rachel to represent that part of the story. She offers an allusive retelling of the narrative of canto XXXIII, one that does not

include every element in it but powerfully highlights certain ones. And she does so in a manner that recalls that of the medieval illuminators she had studied, juxtaposing on the single picture plane elements that occur at different temporal moments in the verbal story. It is a technique she uses elsewhere in her Dante illuminations, and one that is not entirely absent from Rauschenberg's series, but which she uses with remarkable force and assurance.

It is, however, probably not the thing that someone coming to her images for the first time will find most immediately striking. Most illustrators include representations of the figure of Dante (if not so adventurously as Rauschenberg with his young man in white shorts).[8] He is after all present throughout the poem as a character and a voice. It is common to see him as the poem's protagonist, a pilgrim on a journey, and also of course as a poet, discovering and enacting his mission to faithfully report what he witnesses as a lesson to those in the mortal world. We are all likely to have an image of what he looks like – thin-faced, hook-nosed, wearing a scholar's hooded robe (no matter that this image may only have become established in the fifteenth century). Dante is eminently representable. Rachel has no truck with any of this and largely leaves the Dante figure implicit or suggested rather than represented. In the illustration to canto II the dominant photographic image is that of a woman's face, the face of Rachel herself, looking out intently at the viewer. Perhaps the image represents Beatrice. If so, she seems to supersede Dante, who is completely absent. Or it may be that Dante is re-cast as Rachel, as arguably happens in reality through the act of interpreting and illustrating his text. On the other hand, another image of Rachel appears in the canto XX illustration, but the face is labelled here as Manto, the false prophetess who figures in this canto. Rachel, it seems, does not go in for regular coding, either for images of herself or of Dante.

There are also one or two moments when the writer (or narrator or artist) is implicitly present, and strongly so. Hands seize hold of the side of the boat in which Dante is sailing across the river Styx (canto VIII); and again the hands of Brunetto Latini reach up to seize hold of the hem of the robe Dante is wearing (canto XV). Both of these images emphasize the drama of the moment, but neither they nor any other of the illustrations I have mentioned add up to

the sort of foregrounding of the Dante figure we are familiar with. Arguably there is an underlying polemic here, in the sense that Rachel is querying what it is for a woman to read and interpret Dante in the twenty-first century, and either discounting the need for a gendered reading of Dante altogether or proclaiming an inevitable distance from the text for the female reader or viewer.

In many images she seems to be pushing us, or perhaps playfully enticing us, into a territory which it is not easy to interpret. She gives us a series of invitations to turn or return to Dante's text and look at some of its significant features, but she also includes images which may point in quite different directions, based in some cases on photographs of her friends and family. Ugolino gnawing on the head of Archbishop Ruggieri at the end of canto xxxii is a reworked image of a teenager devouring a corn on the cob or something similar; the depictions of the sinners watched over by the devils of cantos xxi and xxii have the air of photos of young boys swimming in the sea; in canto v, Francesca is Rachel's close friend, Fiona (see p. 65). In general there is an emphasis on youth. In canto x Farinata looks far more youthful than the

fifty-two-year-old veteran that he was: the papal legs and feet with flaming soles sticking out of pits in canto xix are boyish or perhaps girlish. And so on. This we may say is not Dante, but it is a way of seeing him that throws into relief a ludic aspect of the experience that most modern readers at some moment surely succumb to, rather than solemnly accepting the horrific and moralizing messages that traditional scholarly and critical interpretations have understandably dwelt on.

In general Rachel gives more prominence to female figures than is usual, achieving, I think, her most striking and affective result in the image of the face of Myrrha (canto xxx), which she presents as a blank, screaming mask foregrounded as thrusting out towards the viewer from the left. Conversely, male figures are less expressive, being often reduced to cartoonish drawings. As the series progresses, however, they take more and more the form of images of ancient statues of Greek or Roman deities, mostly the same ones repeated several times in different roles. Rachel uses these naked figures, familiar and yet remote, to represent both male sinners and figures such as the giants who stand along the rim of the bottommost circle of hell (canto xxxi).

There is obviously an agenda here, one with deep personal resonances, but also one with public, general aspects. It is the combination, or perhaps better, the clash of scholarly exactness of interpretation, alertness to contemporary issues and personal commitment that make Rachel's Dante illustrations such complex and original creations. None, it should be observed in conclusion, would be anything like so impressive or affecting if the actual techniques used to produce these illustrations were not applied with such variety, control and imaginative brilliance.

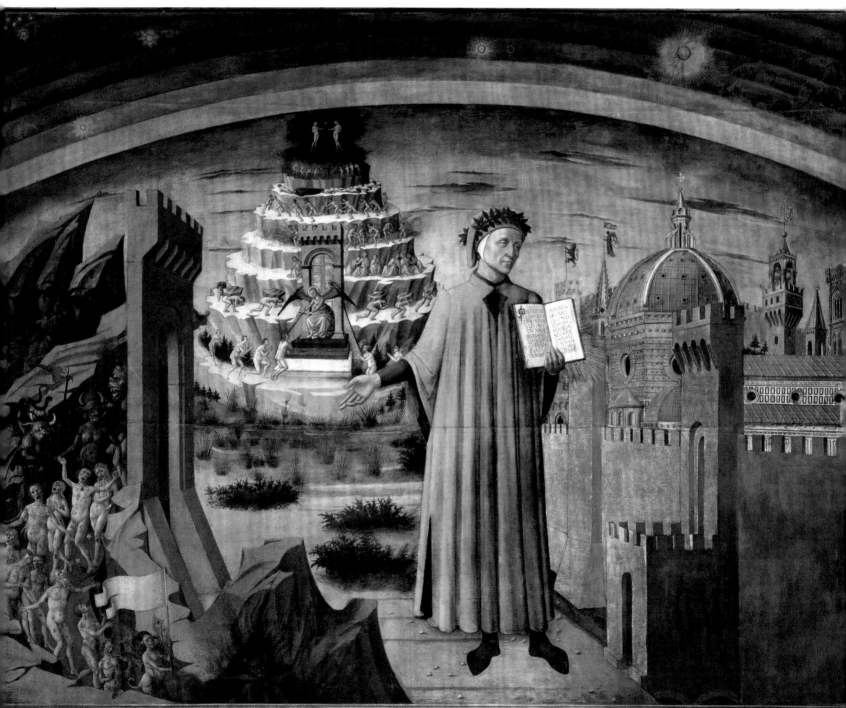

VI COELVM CECINIT MEDIVMQVE IMVMQVE TRIBVNAL · LVSTRAVITQVE ANIMO CVNCTA POETA SVO · DOCTVS ADEST DANTES SVA QVEM FLORENTIA SAEPE
NSIT CONSILIIS AC PIETATE PATREM · NIL POTVIT TANTO MORS SAEVA NOCERE POETAE · QVEM VIVVM VIRTVS CARMEN IMAGO FACIT·

David Bowe

In her cycle of illustrations for Dante's *Inferno*, completed in 2016, Rachel Owen took a radical departure from a nearly seven-century illustrative tradition to offer a new view of the first *cantica* of the *Commedia*. Owen's images draw on the rich history of Dante illustration, which was also her area of academic research, but she provides a fundamentally new perspective on Dante's hell, casting the viewer as a first-person pilgrim through the underworld. The immediate nature of this Dante's-eye-view voyage through the *Inferno* pushes us to question the nature of our encounter with Dante's text. In her illustrations, Rachel Owen highlights and troubles the strata of time, commentary, translation and adaptation that inevitably mediate any reading of Dante's *Commedia*, especially 700 years after Dante completed his poem.

The immediacy of Rachel Owen's *Inferno* plays out across three main aspects of her illustrations: the removal of the figure of Dante from the picture to create a first-person viewing experience; the representation of the Virgilian guide within this new field of vision; and the interaction of text and image across the illustrations. I will refer to these under the three banners of 'The Pilgrim', 'The Guide' and 'The Textual Body'. The last of these is a slightly narrower category than the text–image relationship more broadly, which is discussed in both Fiona Whitehouse's and Peter Hainsworth's pieces in this book, and I choose it for reasons that will become clear below.

The Pilgrim

If there is one iconic figure that we expect to see front and centre in any depiction of the *Inferno*, it is the man who wrote it and cast himself in the leading role: Dante Alighieri. Dante has been depicted in many guises since his death in 1321. We encounter him as author of the material book, as in Domenico di Michelino's famous 1465 fresco in the nave of the Duomo in Dante's native Florence; in the opening initials of numerous manuscripts of his poem; in the stern portraits at the centre of the frontispieces adorning numerous printed editions of his *Commedia*.[1]

We see Dante the pilgrim and protagonist making his way through the afterlife with his guides, now bending to talk to a prostrate sinner, now enraptured by Beatrice's smile. Whether in the fourteenth-century illustrations enriching the Bodleian's Holkham manuscript,[2] or in Botticelli's gloriously unfinished,

Dante and His Poem, Domenico di Michelino, 1465, Florence, Santa Maria del Fiore (tempera on panel).

81

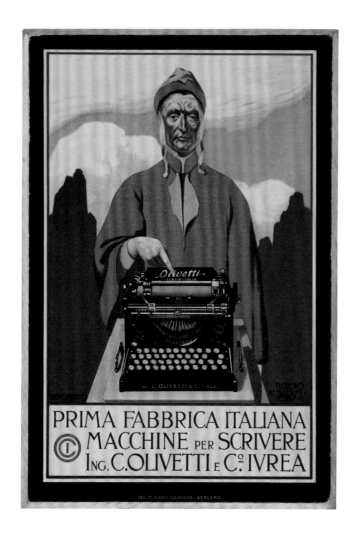

vividly gestural illustrations, made in the last decade of the fifteenth century, Dante is always visible, if not always the focal point.[3] We also meet various versions of Dante – as Mickey Mouse in *Mickey's 'Inferno'*,[4] selling Olivetti typewriters in Teodoro Wolf-Ferrari's 1912 poster, and hacking his way through a computer-animated hell to save Beatrice in EA's 2010 video game.[5]

It is doubly striking, then, that when we look at Rachel Owen's illustrations, there is one figure we never truly see: Dante. From the very first image in the series, we as viewers are presented with a vista devoid of the author as pilgrim, as the icon and mediator who shapes our experience and understanding of the afterlife through which he, by turns, trudges, climbs and soars. For me, it was only after viewing a number of these images that this marked lack of Dante as a visible presence hit home. The illustrative tradition of the *Commedia* creates the expectation that the body of Dante defines the journey through the afterlife, just as it often does in the poem itself: 'I am here with the same body I have always had' ('son col corpo ch'i' ho sempre avuto') (*Inferno* XXIII, 96), Dante tells two damned friars in the sixth ditch (or *bolgia*) of the

above Poster for Olivetti typewriters, Teodoro Wolf-Ferrari, 1912. *opposite* *Inferno* V ii: *Paolo and Francesca*, Michael Mazur, 1996 (monotype on paper).

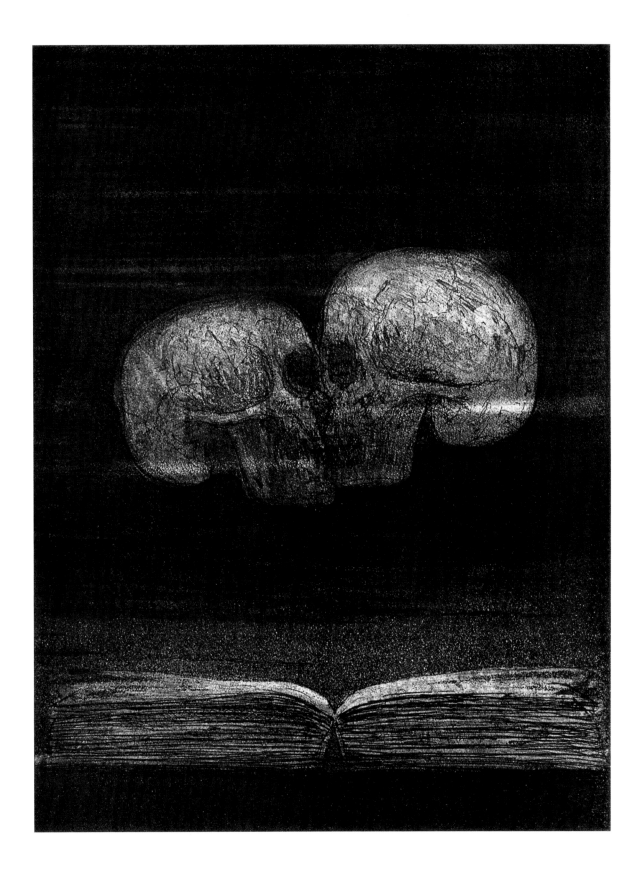

eighth circle of hell, dedicated to the punishment of hypocrites.

Besides Rachel Owen's work, a notable exception to this history of representation comes in the form of Michael Mazur's thirty-six monotype illustrations for Robert Pinsky's translation of the *Inferno*.[6] The series, subsequently expanded to forty-one prints, was exhibited across Italy in 2000, and published in a catalogue with excerpts from Pinsky's translation and a selection of essays.[7] Mazur's images remove both Dante and Virgil entirely from the scene, focusing, in just over one image per canto, exclusively on the fates of the souls of the damned and, on occasion, the tales told by those souls. An example of this double illustration comes in canto v, to which Mazur devotes two images in his expanded series. The first of these, the image included in the illustrated edition of Pinsky's translation, shows the storm forever sweeping the carnal souls before it (v i).[8] The second, produced for the later exhibition, is devoted to Paolo and Francesca, portrayed as two skulls kissing over the book (v ii) that, in Francesca's account, was the go-between that facilitated their damnation ('Galeotto fu il libro', *Inferno* v, 137).[9] Two

crucial aspects differentiate Mazur's work from Rachel Owen's, however. The first is the complete absence of both Dante and Virgil, the Pilgrim and the Guide, and the second is that Mazur sets out to show in his illustrations things that Dante never sees, things that exist or are anticipated in this hell, but are never directly witnessed. A prime example is Mazur's cross-section of the pit piled deep with popes in the third *bolgia* of the circle of fraud (canto xix).[10] This *bolgia* in the eighth circle of hell is dedicated to simoniacs (those who sold ecclesiastical privileges), and in it Dante witnesses the flaming soles of the feet of the damned, poking up out of holes in the ground like plants in an infernal potting shed. Each hole, Dante learns from Pope Nicholas III, is actually stacked many souls deep, but while Dante hears this, Mazur's illustration shows it, necessitating a split between the viewer/reader and the pilgrim travelling through the afterlife. Similarly, Mazur depicts the interior of Charon's boat (iii ii), which Dante never sees, having fallen unconscious for the crossing over the Acheron, from hell's vestibule to the circle of Limbo. For Dante's second river crossing, this time over the Styx (canto viii), Mazur chooses the image of the fire-topped towers on each shore, while

Inferno VIII: *The Tower*, Michael Mazur, 1996 (monotype on paper).

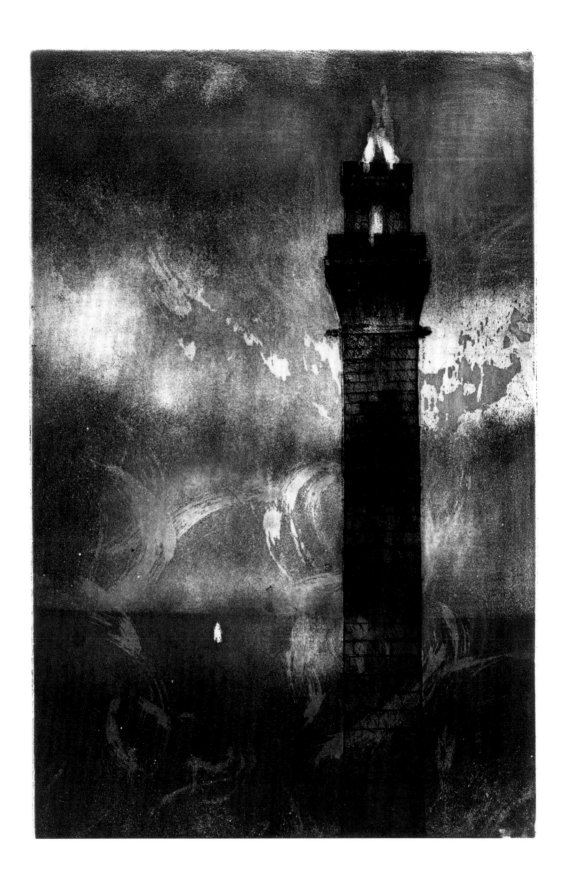

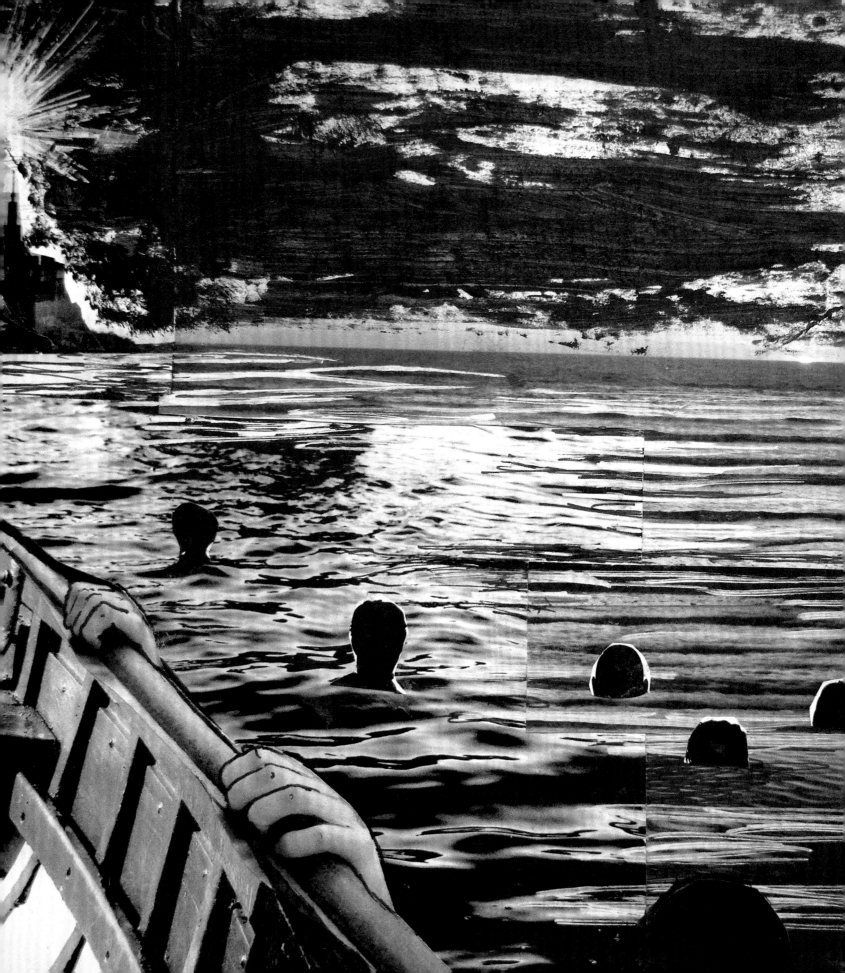

Owen shows us the view from inside the vessel, with Filippo Argenti's hands gripping the side of Phlegyas' boat before the sinner is dragged back into the sullen waters of the infernal river.

In Rachel Owen's *Inferno* illustrations the Guide remains a visible presence and neither, just as crucially, is the Pilgrim actually absent. Rather, with no Dante to assume the journey on our behalf, we are asked to take on the role of the Pilgrim in ways that challenge the idea of viewership and readership, and call for a new kind of engagement. The viewer sees the landscapes, souls and often the concepts of Dante's hell 'directly' from the first-person perspective occupied by the poet himself in the *Commedia*. We are offered a Dante's-eye view of hell. Owen's illustrations invite a level of participation beyond even the video game *Inferno*, in which the player's point of view is third-person, puppeteering a macho Dante whose muscular form is front and centre in the digital hellscape on screen.

With this new outlook on the afterlife, the artist creates an immediacy that implicates the viewer in the scene. This shift in perspective is perhaps most vivid, and also most delicately balanced, in the encounter with Brunetto Latini in canto xv, as Dante's Florentine mentor seizes the pilgrim's robes:

> fui conosciuto da un, che mi prese
> per lo lembo e gridò: 'Qual maraviglia!'
>
> (I was recognized by one soul, who seized
> me by the hem of my garment and cried out:
> 'What marvel is this!')
>
> *Inferno* xv, 23–4

In Dante's telling of the episode, this is an intimate, if inevitably ambivalent reunion with a respected 'maestro', whom the pilgrim addresses with the honorific 'voi', even as the poet condemns him to eternal damnation: 'Siete voi qui, ser Brunetto?' (Are *you* here, master Brunetto?) (*Inferno* xv, 30). In Rachel Owen's depiction, meanwhile, we are given the view of hands gripping garments, yes, but the illustration is arranged in such a way that it is as if the robes belong to the viewer. In a format familiar to players of first-person video games and users of VR headsets, the spectator is asked to take on the body of the pilgrim in this encounter. The absence of identifying features

Inferno VIII: Filippo Argenti gripping Phlegyas' boat, Rachel Owen, 2016 (photographic print of mixed media collage).

(there is no face atop those grasping hands) also allows for some other familiar figure to be imagined in Brunetto's place. Owen's depiction of this encounter, like all of her *Inferno* illustrations, opens up an imaginative space into which the viewer may step.

This is also, as noted above, a delicate, even perilous procedure, as some may find this sudden representation of the Pilgrim's body more alienating than absorbing. This risk is heightened in the depiction of the Pilgrim's hand reaching into the frame to grasp the hair of Bocca degli Abati in the illustration for canto XXXII. The hand, much more specific than the garments of canto XV, raises the stakes, offering either an unsettling sense that the viewer is perpetrating the act in the image, or a clear sense of distance in recognizing that 'that is not my hand'. But even this potential breach of the pure first-person perspective carries with it the possibility of a more immediate engagement in the image. If we accept the role of 'mirror neurons' – neurons that fire when we witness an action performed as well as when we perform that same action – even viewing the hand reaching into the picture to abuse the scalp of Bocca degli Abati could provoke a sense of participation, of complicity in that action.[11] Either way, this gesture ruptures the frame of the image and disrupts any sense of visual and intellectual distance created by the pure third-person perspectives of the illustrative tradition.

These are not simply illustrations of Dante the pilgrim's progress through the afterlife. Rachel Owen's images invite the viewer into an immersive, immediate experience of that afterlife in a wholly new and deeply moving way.

The Guide

> ... 'io sarò tua guida,
> e trarrotti di qui per loco etterno:
> ove udirai le disperate strida,
> vedrai li antichi spiriti dolenti,
> ch'a la seconda morte ciascun grida

> (... I will be your guide
> and lead you from here through an eternal place,
> where you will hear desperate screams
> and you will see the ancient suffering souls
> who cry out at death's second sting)

Inferno I, 113–17

Inferno XV: 'Siete voi qui?' Meeting Brunetto Latini, Rachel Owen, 2016 (photographic print of mixed media collage).

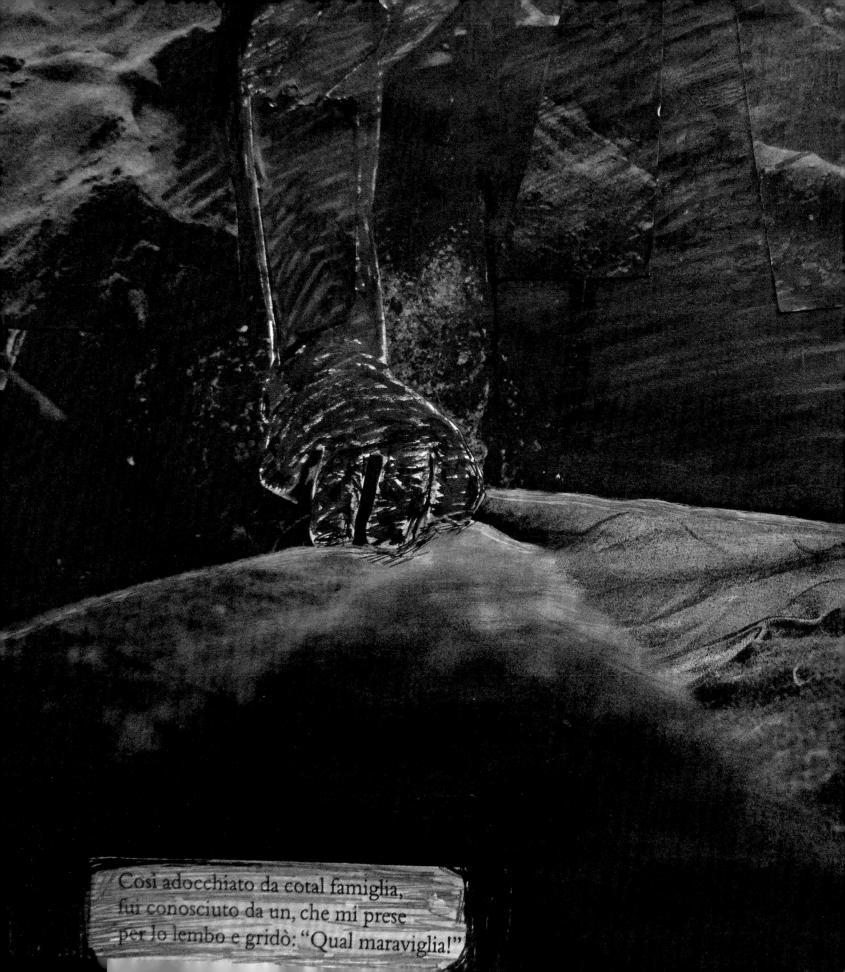

Così adocchiato da cotal famiglia,
fui conosciuto da un, che mi prese
per lo lembo e gridò: "Qual maraviglia!"

The second figure we would expect to see in any depiction of Dante's otherworldly journey is his guide. Over the course of the *Commedia* Dante has three principal guides: Virgil, the famed Roman poet, who leads the pilgrim through hell and purgatory; Beatrice, Dante's late beloved, who acts as his intermediary and instructor while navigating the spheres of paradise; and St Bernard, who serves as Dante's intercessor in preparation for the pilgrim-poet's final vision of the divine. As *Inferno* was the only section of Dante's poem that Owen was able to fully illustrate before her life was cut short, Virgil is the guide we meet in her images. Or at least, Virgil is who we expect to meet. As for the figure of Dante, there are traditions of Virgilian portraiture.[12] He is usually depicted as clean-shaven and often accompanied by the tools of his trade or extracts of his work, as in the mosaic portraits held in the National Bardo Museum in Tunisia and the Rheinisches Landesmuseum Trier in Germany.[13] In later depictions he often wears the leafy crown of a poet laureate, as on the frontispiece made by William Marshall (*c*.1617–1649) for John Ogilby's mid-seventeenth-century translations of the works of Virgil.[14] In many illustrations of the *Commedia*,

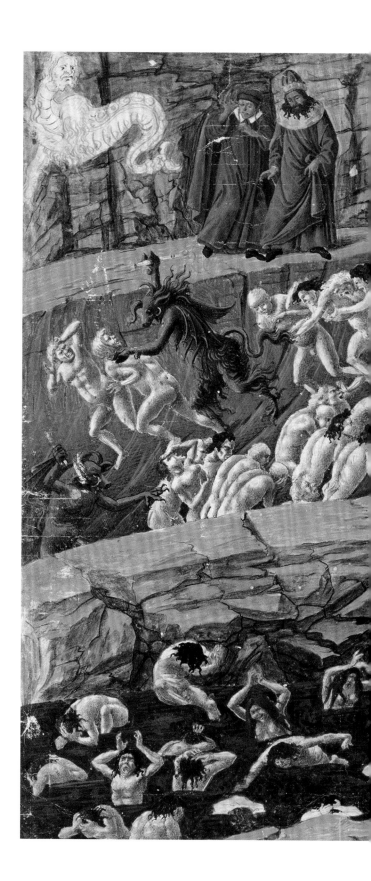

Inferno XVIII: Traversing the Malebolg*e*, Sandro Botticelli, *c*.1485 (gouache on parchment).

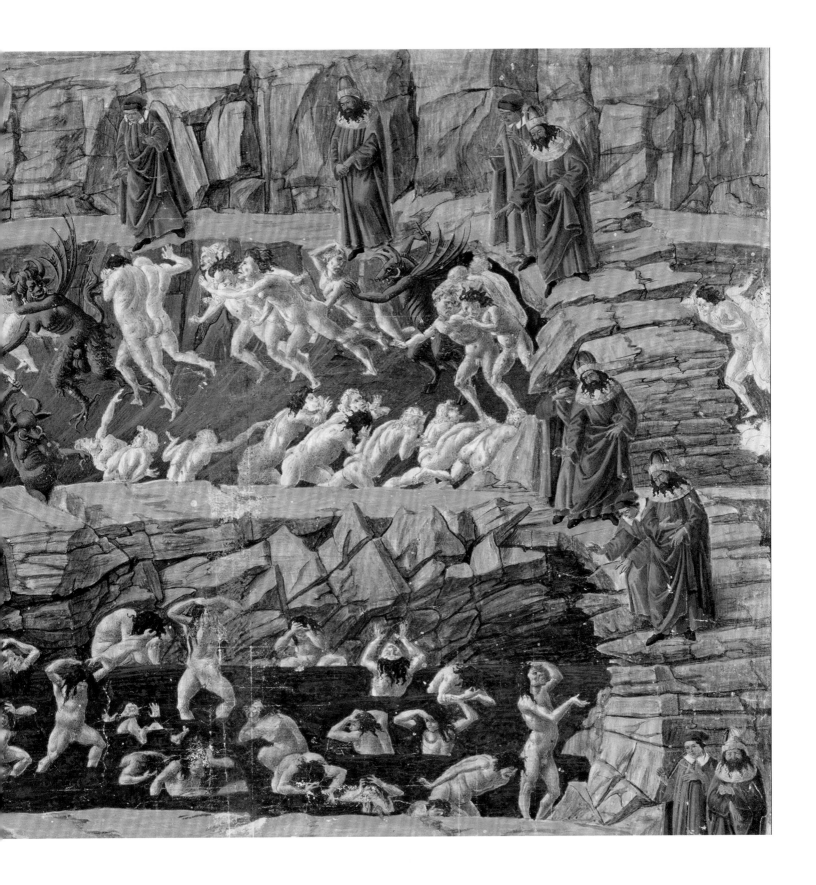

however, Virgil wears a beard and scholarly, or prophet-like, robes, as seen in the Bodleian's Holkham manuscript.[15] This standard model of the magisterial, bearded Virgil still persisted in Botticelli's late fifteenth-century illustrations.

The figure who leads us through Rachel Owen's illustrations, however, is far from the ageing, hirsute Virgil of this Dantean tradition. Our new Guide appears feminine, a possible self-portrait of the artist, and, in a significant visual move, transparent in all but one of their appearances. In the illustration to the second canto of the *Inferno*, Owen shows us the moment in which Virgil explains to Dante that he was, in fact, sent by Beatrice to save the pilgrim from sin and death. We, in our pilgrim's shoes, see this scene play out through the transparency of the Virgil figure, as this first appearance of our Guide is laid over a photographic self-portrait of the artist in the role of Beatrice. The image is literally mediated by Virgil, whose form sits between the viewer and Beatrice. She is identifiable in this scene as the third in a series of holy ladies who intercede on Dante's behalf. The first two of these, the Virgin Mary and St Lucy, are depicted in the top right-hand corner of the illustration, looking down towards Beatrice, who acts as divine messenger and recruits Virgil to lead Dante 'per lo cammino alto e silvestro' (by the deep, wild way) back towards Beatrice and to paradise.

The assimilation of Virgil, Beatrice and the artist through the use of self-portraiture and the blurring of gender in the illustrations provokes some valuable questions about the relationship between artist and poet, text and image, viewer and reader. If the guides of the *Commedia*, both Virgil and Beatrice in this case, take on the physical aspect of the artist, what does that tell us about the artist's relationship with the text being illustrated and our experience of the text through her illustrations? On the simplest level, the artist guides us through the text with her images, the illustrations serving as a commentary and visual aid to our reading of Dante. Beyond this act of mediation – of guided reading – the artist also offers a new approach to authorship, and to the authority of readership. Rather than monumentalizing the authorial figures of Dante and his own 'maestro and autore', Virgil, as we see in many illustrations and artistic responses to the *Commedia* and its poet,[16] Owen opens the image, and thus the text, to the reader by taking the poem,

its author and its first guide down from their cultural pedestals, putting them at our eye-level. The artist inhabits the roles of the guides just as she invites the viewer to inhabit the role of the pilgrim, creating a direct visual rapport between viewer-pilgrim and artist-guide. This compounds the power of the first-person point of view employed throughout the images, to create an affective experience, an immediacy of interaction with Owen's representation of a reappropriated hellscape that is always Dantean, but never entirely Dante's. The viewer is offered a new sort of encounter with the narrative and landscape of the *Commedia*.

The Textual Body

In offering this new encounter, Owen's images illustrate both the *Commedia* itself and the act of reading it. That is to say that they realize the vivid visual world of Dante's *Inferno* (and, in several posthumously discovered illustrations, of the early cantos of *Purgatorio*) and that they stage the experience of reading the poem assisted or distracted by the commentary tradition. Owen's illustrations, then, play with the idea and place of the paratext, the accretions of text (and often image too) that accrue around any widely read, circulated and studied work. Paratext is a term coined by Gérard Genette in a work called *Seuils*, which translates as 'thresholds'. Briefly defined, then, paratext is the thing we cross to access a text, the gateway into reading, and Genette's concept falls into two main subcategories:

1) 'peritext', which is those materials making up a book that are not its 'contents', i.e., the cover, preface, titles, indexes, and the like;

2) 'epitext', which is those materials produced about a book, i.e., reviews, interviews, adverts, etc.[17]

It is notable that Genette's original subcategories make no mention of illustrations or images (though any cover image may be inferred to be a peritext), but this does not mean that they aren't relevant to thinking about Owen's illustrations. Coming at the problem from two ends of the timeline, Charlotte Cooper has shown how illustrations play a vital paratextual role in medieval manuscripts, offering a way into the text by guiding the reader with helpful visual cues;[18] while Ellen McCracken raises the role of a whole range of features, from hotlinks to embedded video, that represent a new kind of paratext in the age of the e-reader. A key aspect of McCracken's expanded categories is the idea of multiple possible

directions of travel across the thresholds provided by different paratexts. Some things draw us into the text (centripetal), other things lead us away from it (centrifugal).[19] Things that lead us out of a digital text might include look-up functions that jump to dictionary definitions, or embedded links to comments on certain passages. Things that draw us into the text might include embedded videos designed to enhance the reading experience, or simply the name of a chapter in the index serving as a link to the beginning of that chapter.[20]

Usually, illustrations (appearing in a book, alongside a written text) would count as 'peritexts' – found in a book but not part of the original written text – but Owen's illustrations were first exhibited (and are printed here) separately from the text of Dante's *Commedia*. As such, they might be considered 'epitexts' – external things that are 'about' the poem. They are still, however, classed as illustrations, calling on the idea of the illustrated text, the image as part of the experience of the text, not 'just' inspired by it. However much they blur subcategories, the *Inferno* illustrations are certainly paratextual in that they are part of material surrounding the *Commedia*, and they are the kind of material that leads us into the text, into the world of Dante's poem. In fact, they also point to, and question, some of the other kinds of paratext surrounding the *Commedia*.

I emphasize this idea of the paratext for two reasons. The first is more personal and tied closely to Owen's own research on the illustrative tradition of the *Commedia*: I first met Rachel Owen at a seminar in which she was presenting her research on the relationship between names and figures in the illustrations of Bodleian MS. Holkham misc. 48. In the beautiful late fourteenth-century illustrations in that manuscript, the individuals depicted are labelled with their names in red ink. The *Inferno* illustrations play with this tradition with the frequent addition of handwritten names labelling certain figures (as in the stark addition of 'Pier' to the tree trunk representing Pier della Vigna in canto XIII) or the application of cut-out text from the poem naming the characters in a scene (the three Guelphs in canto XVI). In her paper, Owen questioned the assumed hierarchy between text and image, and particularly between these rubrics which give names to the illustrated figures and the illustrations themselves.

The second reason is that the artist made a particularly innovative use of texts commenting on the *Commedia* in creating her illustrations, representing a key aspect of her own commentary on both Dante's poem and the history of its interpretation. In her illustrations, as in her research, Owen questions the relationship between paratext and poem, between the words that accrue around the edges of the *Commedia* and serve sometimes as gateways and sometimes as obstacles for readers of the poem.

Two of the most immediate examples of this process are found in the illustrations to cantos I and XXVIII. In canto I, Dante encounters three vicious beasts, the *lonza* (pard) of fraud, the *leone* (lion) of pride and the *lupa* (she-wolf) of cupidity. These beasts have been subject to extensive discussion and commentary, with numerous more or less subtle variations in the understanding of their meaning within the poem. Owen's illustration for the encounter creates the bodies of these allegorical animals out of their entry in the *Dante Encyclopedia*,[21] a gesture that alludes to the level of commentary that these creatures have generated. Visually, the text of the encyclopedia completely obscures the bodies of the beasts: we see

them only in outline, with no features of their own, only the features ascribed to them by the scholarly pen. The pard, the lion and the she-wolf are almost completely dissolved into text, and not even the text of the poem, but the paratextual commentary. It is easy to read into this obscuration a comment on the loss of literal meaning in this episode: the pilgrim is lost, and just as he finds a promising path, he is driven back by these terrifying creatures, fearing again for his life.

Similarly, Bertran de Born, head dangling from his hand, is portrayed as a body of text, clipped from the same *Dante Encyclopedia* (see also p. 74). His personality, albeit a damned one, is obliterated by the commentary on his symbolic function as emblematic of the system of poetic justice operating in Dante's hell: 'Così s'osserva in me lo contrapasso' (And so you see in me the counter-suffering) (*Inferno* XXVIII, 142).[22] The visceral, immediate effect of so many of Owen's images does something to recapture the creatureliness of hell, the bodily forms (if not yet true bodies) that people this infernal realm and should provoke profound reactions, whether of horror, rage or reflection.

Rachel Owen's *Inferno* illustrations are many things. They are arresting, beautiful, unsettling visual representations of the afterlife as described in Dante's fourteenth-century poem. They are images that remind us of the brilliance and the loss of an artist and her art. They are the work of a researcher with deep knowledge and critical understanding of the illustrative tradition born of the *Commedia*. They are the work of a teacher who led so many into a lasting appreciation of Dante's poem. And, as we would expect from a teacher like Rachel, they ask questions of us and encourage us to seek answers for ourselves.

What is the role of illustration in our readings of texts, especially of texts that have been so often illustrated and commented upon?

How do we experience this afterlife when we are forced to confront it without Dante's physical presence to mediate our journey? If Dante is guided by Virgil, who will guide us as we traverse the circles of hell?

Here is a vision of hell. What do you think?

Inferno XXVI: Virgil addresses Ulysses, MS. Holkham misc. 48, p. 40 (detail), *c.*1350.

96

...agua mens also
...lena tu...
...fidulfo
...ger della pura
...el fu arfo
...fimancia
...fin fene
...come allum...
...ma figeme
...e fe laporta
...genal feme
...phe morta
...ol achille
...fi porta · Frauduleti ofiglieri ·

fe dubbia e lingua nellidiar...
...el uccido piaxe nel debito amoze
lo mal zouea penelope far lieta ·
Ma uincer poter entro mine lardoze
...cui aduenir delmondo expte
et delli uicij humani e del ualoze
Ah ruffi me plalto mare apto
fol conun legno e co quella compagna
picciola dala qual no fui diferto ·
Lun lieto e laltro uidi infin lafpagna
fin nel mozrocco e lifola defardi
et laltre de quel mar intorno lagua
Io e compagni erauan uecchi e tardi
quando uenimmo aquella foce ftrecco
oue hercule fegno lifuo riguardi

The Ulysses Canto

(Dante, *Inferno* XXVI)

Jamie McKendrick

Keep gloating, Florence, now that your great name
　　has winged its way across the earth and sea
　　and even hell acknowledges your fame.

There, among the thieves, I met with five
　　of your choicest citizens, who made my blood
　　burn in my cheeks with civic pride.

If morning dreams are dreams that tell what's true
　　soon enough you'll find out what exactly
　　your Tuscan neighbours have in store for you.

Soon? Why not today? Today, in my view,
　　would still seem an exorbitant delay.
　　Your just desserts are so long overdue.

We left – my guide helping me clamber up along
　　that staircase fashioned out of mighty flagstones
　　by which we'd come down earlier on –

And so resumed our lonely journey
　　over the shaly rock, zigzag as a giant jigsaw
　　and far easier to manage on all fours.

I felt the ache of grief. I feel it once again
　　thinking back on what I saw – and need
　　a kind star, at the least, to come to my aid

so I don't distrust my gift of showing forth
　　the facts, and keep a sharp eye on the truth
　　without getting lost in speculation.

Late summer, after sunset, when the heat abates
　　and mosquitoes change guard with swarms of gnats,
　　the labourer who's resting on a hillside

Sees down in the valley – where an hour before
　　he'd been gathering grapes or steering the plough –
　　a host of fireflies like a dust cloud or a ghost dance:

The eighth chasm was flecked like that with fires
　　– tiny flames I followed with my eyes
　　the moment I caught sight of the starry trough.

When bear-avenged Elisha saw the prophet's
　　chariot soar, its horses reared upright
　　and straining their necks towards the skies,

All he could make out was that arcing light
　　rising and rising in a little cloud
　　like a rocket's fiery vapour trail

– Watching those flames had the same effect
　　as they sped along the ditch, and each one kept
　　a sinner secret in its flickering veil.

Inferno XXVI: Virgil addresses Ulysses on behalf of the pilgrim, Rachel Owen, 2016 (photographic print of mixed media collage).

I was on the bridge and leaning out so far
 I had to grip hard on the parapet,
 or else the least nudge would have keeled me over.

And Virgil, who saw me all eyes at this vision,
 said: 'Spirits live inside those flames
 and supply the fuel of their own combustion.'

'Dear Master,' I replied, 'now you've made clear
 the thing I'd surmised, but what I meant to ask
 was who it is that dwells inside that fire

– The one so deeply cloven down its shaft
 that it seems like the double flame that rose
 from Eteocles and his brother on the same pyre.'

His answer came: 'There in the flame is Ulysses
 wracked in tandem with Diomedes: those two
 now linked in fire as anger linked them once.

They groan within the flame for the wooden horse
 whose trapdoor opening opened up the gate
 for the whole future of the seed of Rome.

Within the flame they now lament that trick
 which left Deidamia weeping for Achilles
 and also for their theft of the Palladium.'

I begged my guide that, if the sparks could speak,
 I wouldn't have to wait for the horned flame
 to come our way but that right there and then

It reach us. He praised my eagerness but warned me:
 'However, in this case, you must keep quiet.
 It's no big mystery what you want, so please

Let me do the talking. I have this feeling
 that, being Greeks, they'd find your mode of speech
 a shade repellent, if you'll pardon the phrase.'

So when the bidden flame had shot towards us
 and stopped where my guide had indicated,
 he addressed the flame in the following manner:

'You two who dwell within a single flame,
 if anything I've done has won your favour,
 if I have earned from you some small respect

When I was alive and wrote those epic lines,
 don't disappear but let the one of you
 tell where, having lost his way, he went to die.'

The taller horn of the ancient flame began
 to crimp and crumble, mumbling as it swayed
 as if a wind was tugging it from side to side

– Its tip slid back and forwards like a tongue
 in the act of speech, and then in moving
 it did speak, it spoke aloud and said:

'When I left Circe who kept me landlocked near
 that place Gaeta for a year and more
 – though it was only named by Aeneas afterwards –

No kind thought for my son nor duty towards
 my old father, nor the love I owed
 Penelope, love that might at last have gladdened her,

Could rid me of the overweening urge
 to know in full all that the world contains
 of human vice and human worth.

So I set forth on the high open sea
 with a single ship and that small company
 that remained – that hadn't died or left me.

I saw Spain pass on one side, on the other Morocco
 and saw Sardinia and the other isles
 the sea laps round. I and my men were slow

And old and tired, but still we entered
 the narrow neck of sea where Hercules
 had planted his pillars as a stop sign

For anyone meaning to pass beyond.
 Seville on our right followed Ceüta
 on our left as we ploughed on undaunted.

Brothers – I said – you who, having passed
 thousands of dangers, have now reached the West,
 to the brief span your senses may still grant you

How can you deny this experience
 of all that lies beyond the sun
 – a vast new world without a human sign.

Think what brought you out of non-existence.
 You were not made to live the life of beasts
 but to follow after virtue and knowledge.

With these few words, I honed their appetite
 to travel on to such a heightened pitch
 nothing after would have served to curb it.

We'd set our course away from dawn, veering
 always slightly south, and worked our oars
 like wings to speed us on that mad career.

Night was aswarm with stars from the other pole
 and our own familiar stars had sunk so low
 they hardly peeped above the ocean's floor.

Lit from below, five times the moon
 had filled and failed since we began
 clambering over the steep crests of the ocean,

When the dim outline of the mountain
 first appeared – so huge despite the distance
 it seemed to me beyond all reckoning.

Our joy soon turned to shock when from the new land
 a storm boiled out of nowhere, shot towards us
 and slammed its head against the wooden prow.

As at someone's command, it spun us round
 three times in a gyre of foam and on the fourth
 canted the poop up in mid air and dunked the prow

Till the sea closed over us without a trace.'

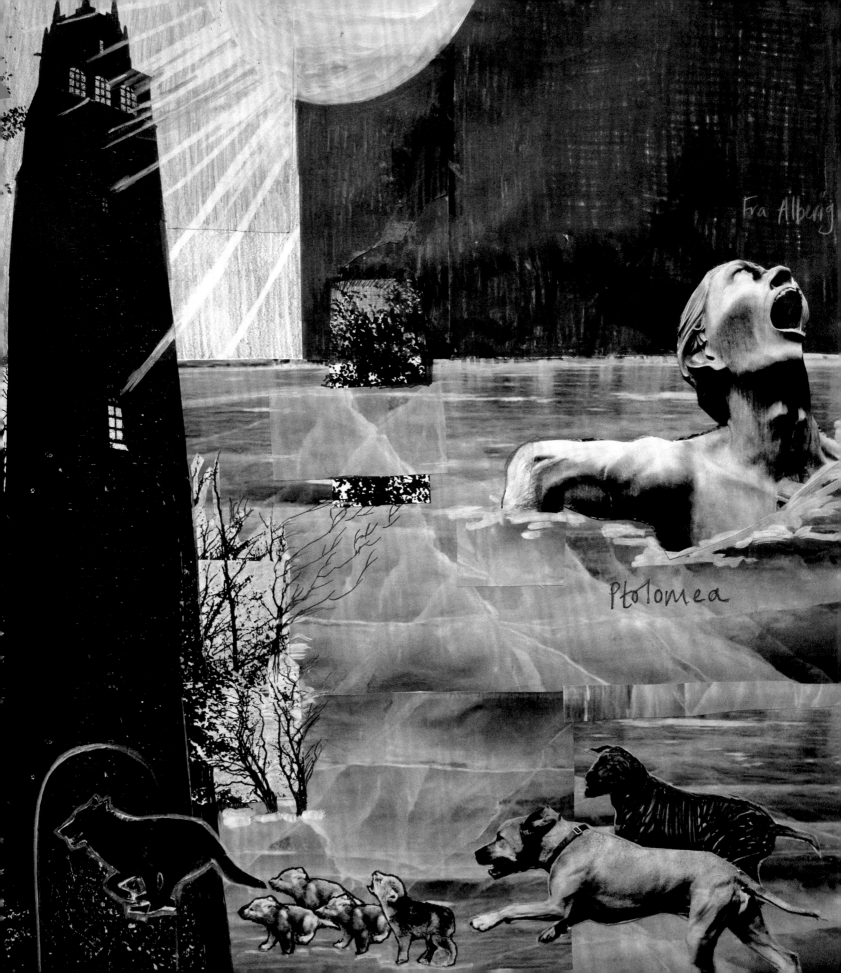

Fra Alberig

Ptolomea

Fra Alberigo's Bad Fruit
(Dante, *Inferno* XXXIII, 91–157)

Bernard O'Donoghue

On we went, till we reached a place where frost
remorselessly confined another group, whose heads
didn't look down but were stuck twisted backwards.

It was crying itself that hindered their ability
to cry, and the misery, impacted at their eyes 95
of ice, ingrown, intensified the agony:

Because the first tears would freeze into a knot,
and, like hard-glass, opaque contact lenses,
filled up the whole space under the eyelids.

And, though the frost had taken every ounce 100
of feeling from my face, making it
like solid muscle to the fingers,

I thought now I felt some touch of breeze,
and asked: 'Master, where can this have come from?
Surely no wind is active in these depths?' 105

Virgil answered, 'Soon we'll reach a place
where you'll see with your own eyes the source
from which this strange current reaches us.'

Then one of those suffering from the frozen
eye-crustcalled out to us: 'You two souls, so evil 110
that you're on your way to the utmost depths
 of Hell,

'Peel off, I beg of you, the hard veils from my face,
so I can release to some extent the grief
trapped in my heart, before the tears freeze
 over again.'

I said to him, 'If you want me to do this, 115
tell me who you are; and, if I do not then anoint
 your eyes,
may I indeed have to go to the iciest part of Hell.'

'All right,' he said, 'I'm Alberigo, the Jovial Friar,
who called for "Fruit!" as the agreed signal to kill.
Now I'm served here with an even sourer fruit.' 120

'But,' I asked him, 'are you then dead already?'
He answered, 'I can't speak for what is happening
 to my physical body in the world above;

'But it's a privilege of this Ptolemaic Hell
that often souls fall down into its depths 125
before Death has severed them from life.

Inferno XXXIII: Grasping Fra Alberigo's hair, Rachel Owen, 2016 (photographic print of mixed media collage).

'And, to persuade you more readily to remove
the jagged glass tears off of my face,
let me tell you that, at the very instant

'when the soul turns traitor, its body is possessed 130
by a demon that stays in charge of it
until its allotted time of life is over;

'But the soul falls straight down to this abyss.
Take this shade who winters here behind me –
maybe his body is still on earth as well. 135

'If you've just come, you'll know. Is Branca D'Oria
still up there? For it's many a long year
since he was shut here in this fellowship.'

'You must be lying to me,' I said to him.
'Branca D'Oria's still alive; he eats and drinks 140
and sleeps and puts his clothes on him.'

'It's not true. Michael Zanche had not yet arrived
in that upper ditch, the Malebranche,
where the vortex of the clinging pitch is boiling,

'When this Branca left a devil in his body 145
in the world above; the same with one of his
 cousins
who collaborated in his treachery.

'But come on; reach out your hand to me;
open my eyes.' But I didn't open them for him;
and being boorish to the likes of him was courtesy. 150

People of Genoa! Strangers to every decency
and disfigured by every vice conceivable,
why are you not wiped clean off the face of the
 earth!

For down with the very worst soul from Romagna
I came on one of yours who, because of his deeds, 155
already bathes in Cocytus in spirit
while up in the world he seems bodily alive.

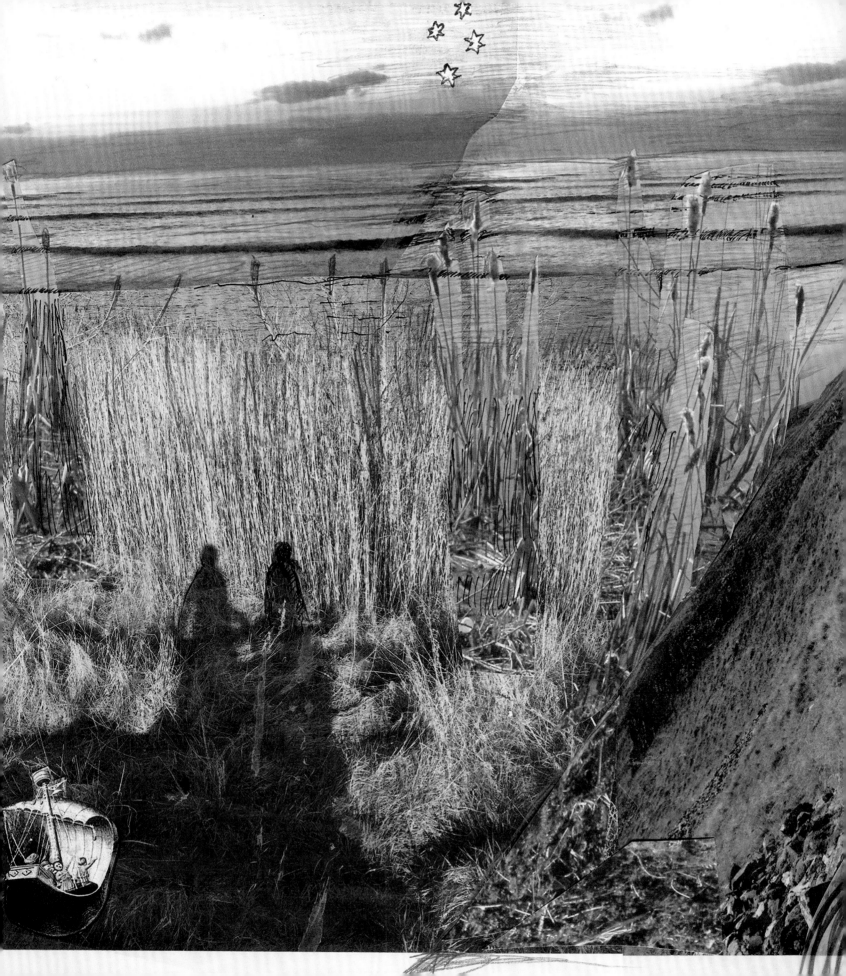

Singing the Second Realm
The Beginnings of *Purgatorio*

David Bowe and Fiona Whitehouse

While sitting at Rachel's desk examining the original illustrations, it struck me as odd that she should finish so neatly at the end of Inferno *when her intention had always been to depict the entire poem. Her parents searched her study with me, and we found six folded collages in a box placed high on a bookshelf. We unfolded them and saw that they corresponded to the first six cantos of the* Purgatorio. *The images are full of love, laughter and colour reflecting the changed atmosphere of the verse, which leaves behind the poetry of the damned. Seeing the images for the first time was a deeply emotional experience. I had come to believe that the end of Rachel's life had somehow mirrored parts of Dante's* Inferno, *but these images offered a different narrative.*

Fiona Whitehouse

After his gruelling journey through the darkness of hell, Dante emerges, grimy and blinking, into the light. The closing line of the *Inferno* recounts how 'uscimmo a riveder le stelle' (we emerged to see again the stars) (*Inferno* XXXIV, 139) and the otherworldly voyage continues into a new realm, a realm of light and promise:

> e canterò di quel secondo regno
> dove l'umano spirito si purga
> e di salire al ciel diventa degno.
> Ma qui la morta poesì resurga

> (and I will sing of that second realm
> where the human soul purges itself
> and becomes worthy of its ascent to heaven.
> May the poetry of death rise up here)

Purgatorio I, 4–7

That second realm is purgatory, the region of the afterlife in which penitent souls pay for and purge their sins in anticipation of heaven. This aspect of the afterlife was still a new concept when Dante wrote his poem: the noun 'purgatorium' first appeared in

the 1170s,[1] while purgatory as a place started to take shape in the following decades in vision literature such as *St Patrick's Purgatory* (the *Tractatus de Purgatorio Sancti Patricii*), written in Ireland in the 1180s.[2] It was not until the Second Council of Lyons in 1274 that purgatory as a place in which penitent souls cleansed their remaining sin before passing to paradise became official doctrine in the Latin (Catholic) Church, though it had obviously become a widely accepted concept before receiving this seal of approval.[3] Writing in the first decades of the fourteenth century, Dante had remarkable freedom in depicting purgatory and his efforts came to shape this realm of penance in the popular imagination for centuries to come. At the centre of Dante's vision of purgatory, as described in the second part of the *Commedia*, is a mountain made up of seven terraces, each dedicated to one of the seven deadly sins: Pride, Envy, Wrath, Sloth, Avarice, Gluttony and Lust. This mountain is crowned by the Earthly Paradise, Eden regained, and it sits on an island on whose deserted shore ('lito desserto') (*Purgatorio* I, 130) Virgil prepares Dante for a long climb. It is the first events on this shore, commonly known as the ante-purgatory, that Rachel Owen

illustrated in the six unfinished images discovered in the artist's study.

These six illustrations, which depict the arrival on the shore of purgatory and encounters with souls who were late to repent of their sins, were based on collages in which broad, bright landscapes take centre stage. Like the *Inferno* collages they are preparatory works that would eventually have been photographed and printed to create a more consistent finish. And like the majority of the *Inferno* collages these are images created from multiple pieces of paper onto which the artist glued and added photographic cut-outs, irregularly cut images, text, passages of paint and pencil and sections of tracing paper.

However, the colour and lighting of these images is not dark and agitated as we see in the *Inferno* illustrations. Rather they are calm and serene, to reflect the fact that all the souls in this realm are destined for salvation. Colours are luminous so the viewer can easily and comfortably navigate the passages they fill. With the exception of canto v, which appears almost uniformly grey in tone, stretches of different blues are used to depict the

vast skies of purgatory, recalling the 'dolce color d'orïental zaffiro' (sweet colour of oriental sapphire) (*Purgatorio* I, 13) that suffuses this second realm. The blue is especially intense in canto VI, in which we see a map of Italy included in the background. Sandy colours permeate the rest of the images. Mount Purgatory, which the souls must climb to reach salvation, appears in five of the six cantos and is constructed from superimposed images of rocks on which Rachel used black ball-point pens to emphasize sections and ridges in the stone.

The empty shore of canto I, in which the pilgrim and the guide, represented as shadows, find themselves on the coast looking out to sea, is made up of images of pale golden grasses and rushes, the 'erbetta' and 'giunchi' described in lines 124 and 102 of canto I, respectively. Here we are again reminded of our embodied point of view, as we gaze at a shadow as if we ourselves cast it into the image.

Rachel's children also make key appearances in the *Purgatorio* collages, continuing the use of family photos from the *Inferno* illustrations, and in canto II her son is Dante's friend Casella, who explains how an angelic ferryman carries souls to purgatory. He then sings one of Dante's own poems to the pilgrim – the *canzone* 'Amor che ne la mente mi ragiona' (Love, who speaks to me within my mind), the opening lines of which form part of the collage (*Purgatorio* II, 94–119). For the foreground of this scene, the artist used two overlapping images of sandy beaches and repeats the first-person view down to the pilgrim's feet, previously shrouded in a bluish robe (*Inferno* XV), now bare and flecked with sand. This image, redolent of a day out at the seaside, emphasizes the more optimistic mood of this second realm of the afterlife.

The artist's son also appears – as a figure drawn on tracing paper – flanked by an image of Rachel's shadow in canto III. Here he is in the role of the laughing, excommunicated nobleman, Manfred. Manfred was the son of Emperor Frederic II, who is among the entombed heretics encountered in *Inferno* X and XI, and this is one of many echoes and reversals of infernal encounters in *Purgatorio*. The shadow is also significant, as it represents the shadow of the Pilgrim, seen by the startled souls (who do not cast shadows themselves):

Come color dinanzi vider rotta

la luce in terra dal mio destro canto,

sì che l'ombra era da me a la grotta,

restaro, e trasser sé in dietro alquanto

(As they saw the light break

on the ground to my right,

so that my shadow was cast on the rock face,

they stopped short and drew back a way)

Purgatorio III, 88–91

As in the image for canto I, we are presented with a shadow that could be our own, inviting our participation in the image, or could depict the shadow of the artist in her work. This feature of the *Purgatorio* illustrations, perhaps more strongly than the infernal images, implies the collaboration between artist and viewer. This sense of collaboration is fitting for a realm in which community is slowly rebuilt through collective penance in preparation for the communion of saints in paradise, '[il] chiostro / nel quale è Cristo abate del collegio' (the cloister where Christ is abbot of the community) (*Purgatorio* XXVI, 128–9).

The crouched figure in the illustration of canto IV is also represented by an image of the artist's son, this time a photograph. Here he represents Dante's lazy old friend, Belacqua, who sits hugging his knees, with his head lolling between them ('sedeva e abbracciava le ginocchia, / tenendo 'l viso giù tra esse basso', *Purgatorio* IV, 107–8), and who gently pokes fun at the poet during their encounter. This canto also gives a long description of the mountainous climb up the steep rock face. Indeed, the collage is dominated by the mountain stone which the souls must ascend.

In canto V we meet three souls who tell Dante of their violent deaths, two in battle and one at the hands of her husband. A photograph of the artist's daughter represents Pia de' Tolomei, the soul of the woman killed in an incident of domestic violence. Unlike the *Inferno*'s Francesca da Rimini, who was also killed by her husband, Pia offers little of her history. Nonetheless Rachel puts this favoured character centre stage looking directly at the viewer, her prominence reinforcing the parallel between these two souls in Dante's poem.

In the last found collage, which represents canto VI, images of the artist's son and cut-outs of his hands

represent the pressing crowd of souls who died violently and who are eager to speak with the poet. In this final illustration the artist included a touching picture drawn on tracing paper, of Virgil embracing another Mantuan poet, Sordello, while a map of Italy hovers above them. This map serves a dual purpose: to show the city that joins Sordello and Virgil in fellowship, despite the centuries that lie between their births; and to give shape to the long political diatribe in this canto. Here, as in the sixth cantos of both the *Inferno* and the *Paradiso*, Dante embarks on dissections of everything wrong with earthly governments and those they govern. In the *Inferno* his target was Florence, in the *Purgatorio* his scope broadens to encompass all of Italy, and in the *Paradiso* it zooms out again to include the whole Holy Roman Empire.[4]

Purgatory is a realm of souls in progress, and even though Rachel's work on this second canticle of the *Commedia* was itself still in progress, and might well have been revised and refined, the images she produced for the first six cantos are already a sure indication of the direction she would have followed. When Dante speaks of this second realm that he has just entered, he looks forward to 'sailing better waters' ('correr miglio acque') and leaving behind the 'cruel sea' ('mar sì crudele') of hell to follow the path of penitent souls towards paradise (*Purgatorio* I, 1–3). These preliminary studies show how sensitive Rachel Owen was to this radical shift of atmosphere, how attentive to the subtleties of the spaces and encounters in this second realm, and how keenly her images engage with and communicate the *Commedia* as a visionary and visual experience.

The Purgatorio Illustrations

The Beginnings of Purgatorio

Rachel Owen

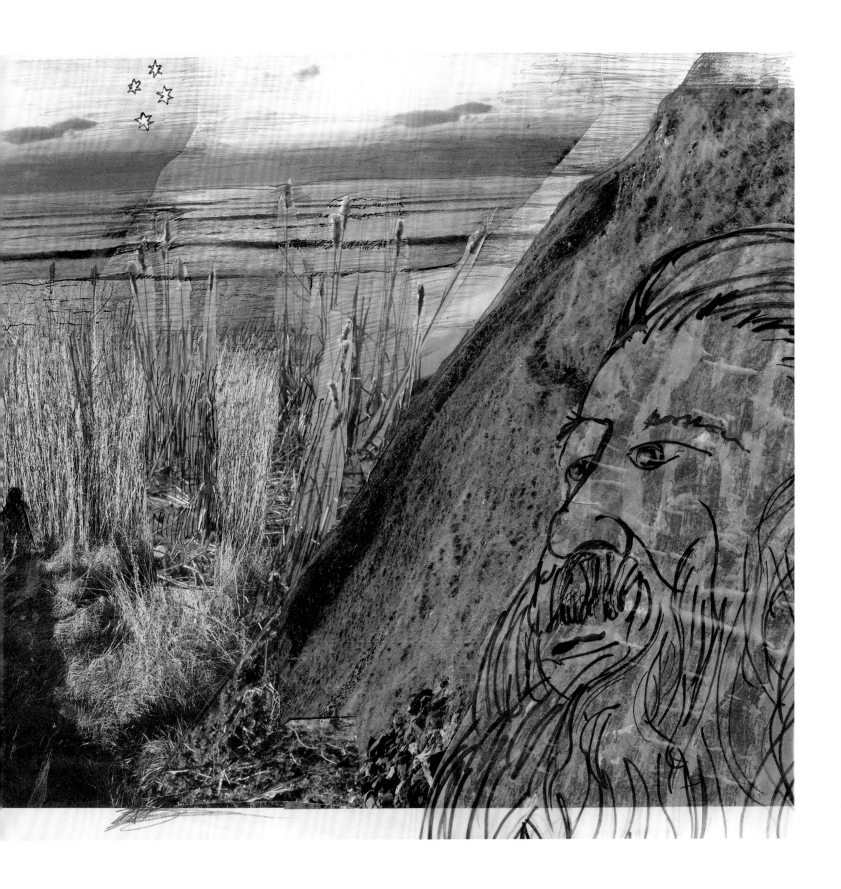

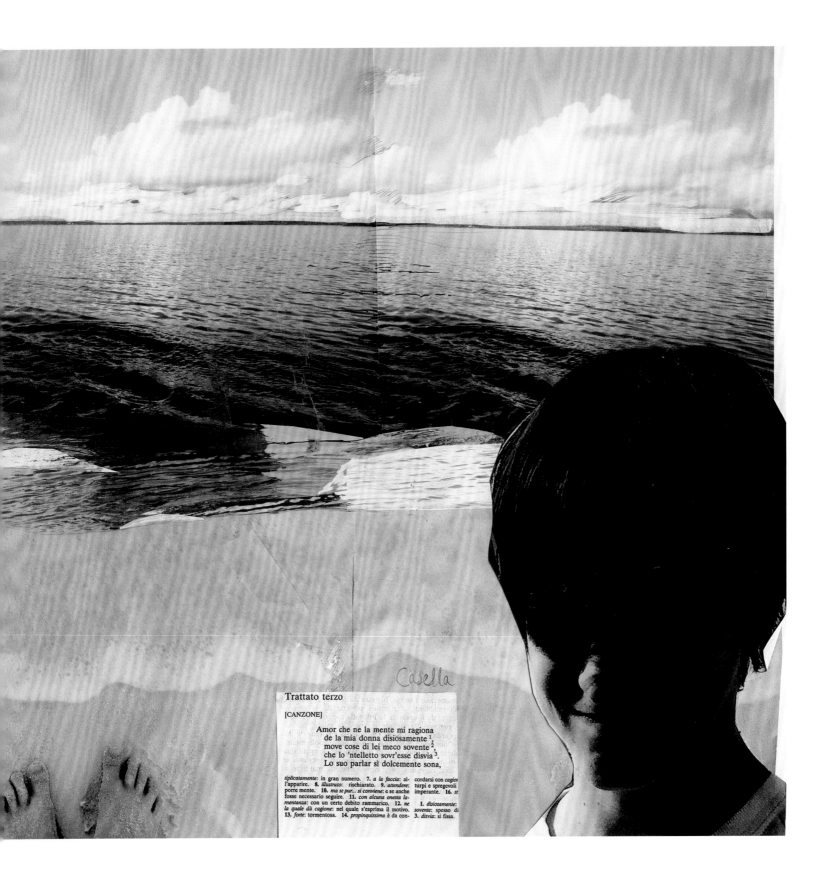

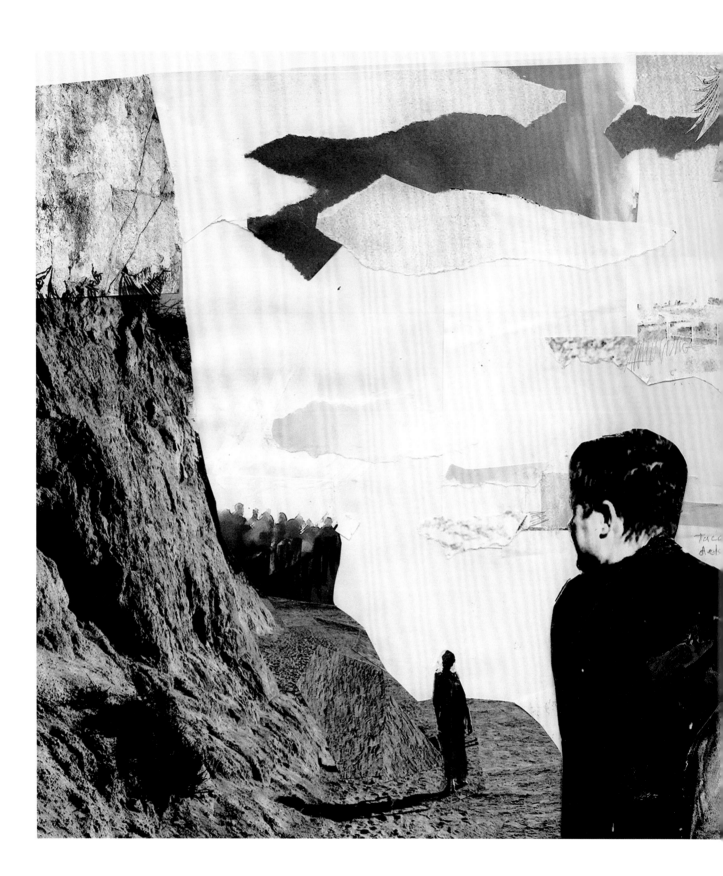

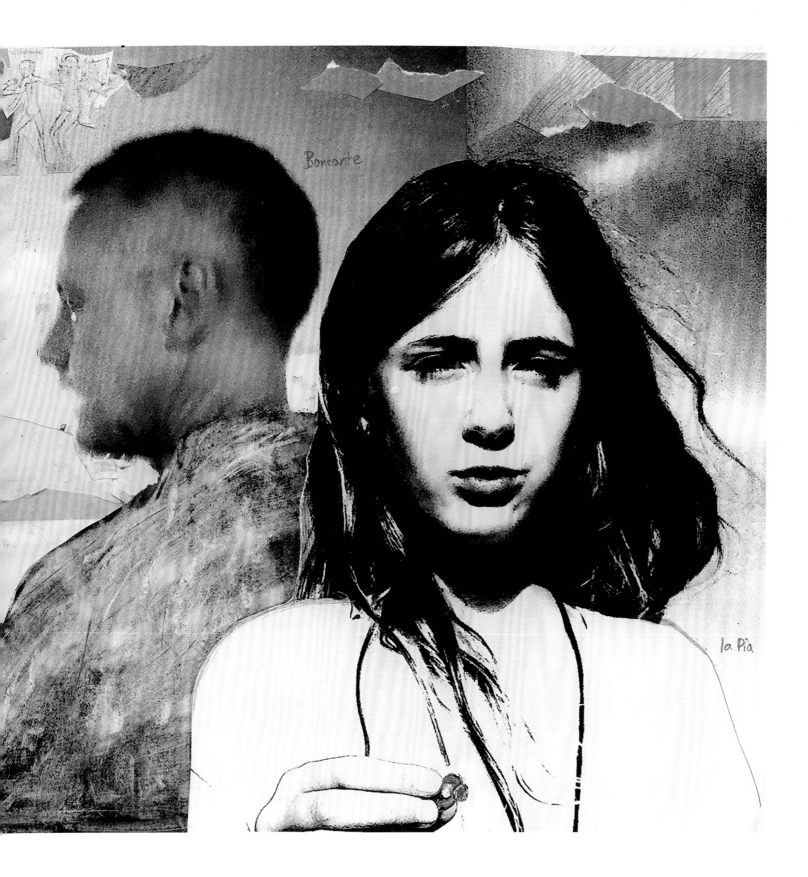

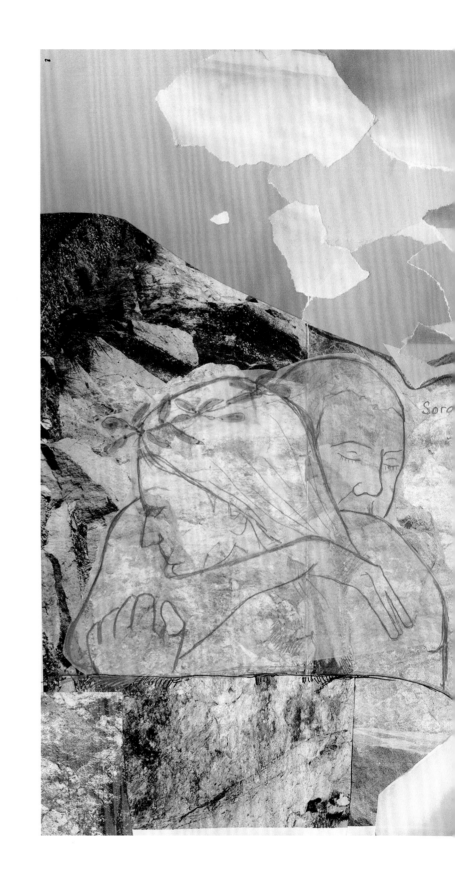

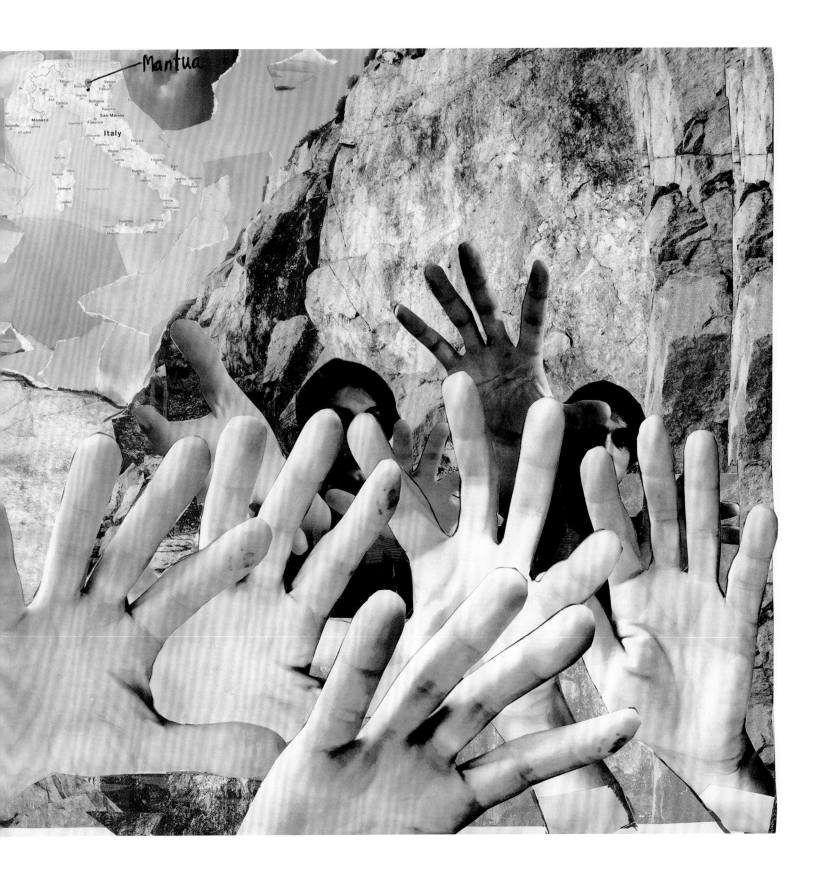

Contributors

Guido Bonsaver is Professor of Italian Cultural History at the University of Oxford and Fellow of Pembroke College. He is particularly interested in cultural change in nineteenth- and twentieth-century Italy and is currently working on a book on the perception of US culture in pre-Second World War Italy. His most recent book is *Mussolini censore: storie di letteratura, dissenso e ipocrisia* (Laterza, Rome and Bari, 2013).

David Bowe is an Irish Research Council Government of Ireland Postdoctoral Fellow at University College Cork. He held a Victoria Maltby Junior Research Fellowship at Somerville College and taught Dante at Pembroke College, Oxford. He works on medieval Italian literature and his first book is *Poetry in Dialogue in the Duecento and Dante* (Oxford University Press, 2020).

Peter Hainsworth is an Emeritus Fellow of Lady Margaret Hall, Oxford, and has written widely on Italian literature. Recent publications include *A Very Short Introduction to Dante* (Oxford University Press, 2015), with David Robey, and *Tales from the Decameron* (Penguin, London, 2015). His edition of John Dickson Batten's illustrations to Dante's *Inferno* will be published by Panarc in 2021.

Jamie McKendrick has published seven books of poems and, most recently, *The Years* (Arc, Todmorden, 2020), a chapbook which includes his art work, and a book of essays on art, poetry and translation, *The Foreign Connection* (Legenda, MHRA, Cambridge, 2020). He has also translated all six books of Giorgio Bassani's *The Novel of Ferrara* (Norton, New York City, 2018).

Bernard O'Donaghue taught medieval English literature at Magdalen College and at Wadham College, Oxford, where he is an emeritus fellow. He wrote a paper on Dante for the Medieval B.Phil. in 1971, and he has published seven books of poems, many on medieval themes, including *Outliving* (Chatto & Windus, London, 2003) and *The Seasons of Cullen Church* (Faber and Faber, London, 2016).

Fiona Whitehouse studied Fine Art and Italian at the University of Exeter and painting at the Accademia di Belle Arti in Florence. She went on to study a masters in the History of Art and Visual Culture at the University of Oxford and was awarded a PhD on fifteenth-century painting techniques from Birkbeck College, London. Fiona is an artist and works at the University of Oxford.

Notes

Rachel Owen 1968–2016

1. Rachel Owen, 'Illuminated Manuscripts of Dante's *Commedia* (1330–1490) in their Cultural and Artistic Context', unpublished PhD thesis, Royal Holloway, University of London, 2001.

2. Rachel Owen, 'Dante's Reception by 14th- and 15th-century Illustrators of the *Commedia*', in Claire E. Honess (ed.), 'Current Trends in Dante Studies', *Reading Medieval Studies*, vol. XXVII, 2001, pp. 163–225.

3. Owen, 'Dante's Reception', p. 182.

4. Rachel Owen, 'The Image of Dante: Poet and Pilgrim', in Antonella Braida and Luisa Calè (eds), *Dante on View: The Reception of Dante in the Visual and Performing Arts*, Ashgate, Aldershot, 2007, pp. 83–94 (p. 84).

5. Richard Thayer Holbrook, *Portraits of Dante from Giotto to Raphael*, P.L. Warner, London, 1911, p. 14, as cited in Owen, 'The Image of Dante', p. 85.

6. 'L'Intervista', *La Repubblica Firenze* (23 September 2012) <https://firenze.repubblica.it/cronaca/2012/09/23/news/rachel_l_altra_artista_di_casa_yorke_a_firenze_mi_innamorai_di_dante-43044420/?refresh_ce> [accessed 19 August 2020].

Remaking the Inferno

1. Rachel Owen, 'Illuminated Manuscripts of Dante's *Commedia* (1330–1490) in their Cultural and Artistic Context', unpublished PhD thesis, Royal Holloway, University of London, 2001.

2. Oxford, Bodleian Library, MS. Holkham misc. 48.

3. In the political turmoil of the Italian peninsula, the Guelphs were a faction who broadly supported the papacy and its political ambitions, while the Ghibellines were aligned with the Holy Roman Emperor in opposing them. Florence was a hotbed of interparty conflict, with both sides (and later the sub-factions of the Black Guelphs and White Guelphs) alternating control of the city through warfare and political manoeuvring. It was as a result of the Black/White Guelph conflict that Dante was exiled from Florence in 1302.

An Original Vision

1. On Batten, see Peter Hainsworth, 'John Dickson Batten's Illustrations to the *Inferno*' in Guido Bonsaver, Brian Richardson and Giuseppe Stellardi (eds), *Cultural Reception, Translation and Transformation from Medieval to Modern Italy*, Legenda, MHRA, Cambridge, 2017, pp. 239–56.

2. *Dante's Inferno*, translated, illustrated, designed and published by Tom Phillips, Talfourd Press, London, 1983; *Hell: Dante's Divine Trilogy Part One. Decorated and Englished in Prosaic Verse by Alasdair Gray*, Canongate, Edinburgh, 2018 and *Purgatory: Dante's Divine Trilogy Part One. Decorated and Englished in Prosaic Verse by Alasdair Gray*, Canongate, Edinburgh, 2019.

3. First published with a German translation: Karl Vossler (trans.), *Die Göttliche Komödie*, Faber & Faber, Leipzig, 2002.

4. Longfellow papers quoted by Kathleen Verduin, 'Dante in America: The First Hundred Years', in Michele Moylan and Lane Stiles (eds), *Reading Books: Essays on the Material Text and Literature in America*, University of Massachusetts Press, Amherst, 1996, pp. 16–51 (p. 24).

5. Mary Jo Bang (trans.), *Dante Alighieri: Inferno*, drawings by Henrick Drescher, Graywolf Press, Minneapolis, 2012.

6. Leah Dickerman, Kevin Young and Robin Coste Lewis, *Robert Rauschenberg: Thirty-Four Illustrations for Dante's Inferno*, MoMA, New York, 2017.

7. Michelangelo Picone (trans. Robin Treasure), 'Bertran de Born', and Lino Pertile, 'Contrapasso', in Richard Lansing (ed.), *The Dante Encyclopedia*, Garland, New York, 2000, p. 100 and pp. 219–22.

8. Other daring Dantes include Sandow Birk's schlubby pilgrim in *Dante's Divine Comedy*, text adapted by Marcus Sanders and Sandow Birk, Chronicle Books, San Francisco, 2004–5; and Seymour Chwast's pipe-smoking, trenchcoat-wearing Dante in his 1920s gangster-styled adaptation, *Dante's Divine Comedy*, Bloomsbury, London and New York, 2010.

Hell, a Pilgrim's-Eye View

1. The emergence and implications of this mode of portraiture are explored in Joshua Reid, 'Textual Physiognomy: A New Theory and Brief History of Dantean Portraiture', *California Italian Studies*, vol. 6, issue 1, 2016, unpaginated <https://escholarship.org/uc/item/2519f0xw> [accessed 1 June 2020].

2. On these and other depictions of Dante, particularly in the fifteenth-century manuscript tradition, see Rachel Owen, 'Dante's Reception by 14th- and 15th-century Illustrators of the *Commedia*', in Claire E. Honess (ed.), 'Current Trends in Dante Studies', *Reading Medieval Studies*, vol. XXVII, 2001, pp. 163–225; and 'The Image of Dante, Poet and Pilgrim' in Antonella Braida and Luisa Calè (eds), *Dante on View: The Reception of Dante in the Visual and Performing Arts*, Ashgate, Abingdon, 2007, pp. 83–94. For a survey of Dante's reception in the visual arts, see Lucia Battaglia Ricci, *Dante per immagini: Dalle miniature trecentesche ai giorni nostri*, Einaudi, Turin, 2018.

3. See Heather Webb, 'Botticelli's Illustrations of Dante's *Paradiso*: The Construction of Conjoined Vision', *I Tatti Studies in the Italian Renaissance*, vol. 22, no. 2, 2019, pp. 187–208.

4. Guido Martina and Angelo Bioletto, *L'inferno di Topolino*, in *I classici della letteratura Disney*, no. 3, RCS Quotidiani, Milan, 2006, pp. 17–89.

5. *Dante's Inferno: The Divine Comedy Video Game*, Electronic Arts, 2010: 'a third-person action adventure game based off the Dante Aligheri's [*sic*] epic poem, *The Divine Comedy*', <https://www.ea.com/games/dantes-inferno> [accessed 11 January 2020].

6. Robert Pinsky (trans.), *The Inferno of Dante: A New Verse Translation*, illustrated by Michael Mazur, Farrar, Straus & Giroux, New York, 1994.

7. Michael Mazur, *L'Inferno di Dante: Opere Grafiche/Graphic Works 1992–2000*, Electa, Milan, 2000.

8. Illustrations are referenced according to the final numbering in Mazur, *L'Inferno di Dante*. For example, (v i) indicates canto v, illustration 1.

9. Galeotto, or Gallehault, features in the prose Lancelot Grail cycle. In this Romance tale, Sir Gallehault, who is a close companion of Lancelot, is instrumental in engineering a similarly adulterous kiss between Lancelot and Guinevere. See Elena Lombardi, '"A Gallehault Was the Book": Francesca da Rimini and the Manesse Minnesanger Manuscript', *Mediaevalia*, 35, 2014, pp. 151–76.

10. Mazur uses this example himself when discussing his illustrations. 'What I had to do often was to imagine how you don't have to see an image only as he [Dante] describes it, but how you might see things that the pilgrim Dante didn't see'; Robert Pinsky and Michael Mazur, 'A Conversation about *The Inferno of Dante*', *The Harvard Review*, no. 8, 1995, pp. 60–71 (p. 62).

11. On some of the potential implications of mirror neurons in our understanding of art and literature, see Heather Webb's contribution to Derek Duncan and Heather Webb, 'Corporealities in Italian Studies', *Italian Studies*, Special Issue, vol. 75, issue 2, 2020, pp. 176–93; and, in a more specifically Dantean context, Heather Webb, *Dante's Persons: An Ethics of the Transhuman*, Oxford University Press, Oxford, 2016, pp. 49, 69, 100 n.56, and 202 n.131. See also a set of articles in dialogue: Vittorio Gallese and Hannah Wojciehowski, 'How Stories Make Us Feel: Toward an Embodied Narratology'; Deborah Jenson and Marco Iacoboni, 'Literary Biomimesis: Mirror Neurons and the Ontological Priority of Representation'; and Carla Freccero, 'Response: Mirrors of Culture', all in *California Italian Studies*, vol. 2, issue 1, 2011, unpaginated.

12. For a survey, see Jan M. Ziolkowski and Michael C.J. Putnam (eds), *The Virgilian Tradition: The First Fifteen Hundred Years*, Yale University Press, New Haven, 2008), pp. 427–62.

13. The Bardo mosaic is featured as one of the museum's 101 masterpieces available to view at <http://www.bardomuseum.tn> [accessed 13 January 2020]. The portrait in the Monnus mosaic in Trier is visible in the *Ancient History Encyclopedia*, <https://www.ancient.eu/image/5836/portrait-of-virgil/> [accessed 13 January 2020].

14. John Ogilby (trans.), *The Works of Publius Virgilius Maro*, printed by T.R. and E.M. for John Crook, London, 1649.

15. Owen, '14th- and 15th-Century Illustrators of the *Commedia*', pp. 181–2; Ziolkowski and Putnam, *The Virgilian Tradition*, pp. 448–51.

16. For a number of pertinent treatments of the artistic reception and political appropriation of Dante in different contexts, including illustration, painting and public monuments, see Battaglia Ricci, *Dante per immagini*; Luigi Scorrano, 'Il Dante "fascista"', *Deutsches Dante-Jahrbuch*, vol. 75, issue 1, 2000, pp. 85–124; Benjamin Martin, 'Celebrating the Nation's Poets: Petrarch, Leopardi, and the Appropriation of Cultural Symbols in Fascist Italy', in Roger Crum and Claudia Lazzaro (eds), *Donatello Among the Blackshirts: History and Modernity in the Visual Culture of Fascist Italy*, Cornell University Press, Ithaca, New York, 2005, pp. 187–202; the introduction to Simon Gilson, *Dante and Renaissance Florence*, Cambridge University Press, Cambridge, 2005; Anne O'Connor, 'Dante Alighieri – from Absence to Stony Presence: Building Memories in Nineteenth-Century Florence', *Italian Studies*, vol. 67, issue 3, 2012, pp. 307–35.

17. Gérard Genette, *Paratexts: Thresholds of Interpretation*, trans. Jane E. Lewin, foreword by Richard Macksey, Cambridge University Press, Cambridge, 1997, pp. 1–3. Originally published as *Seuils*, Éditions du Seuil, Paris, 1987.

18. Genette's paratext was initially and explicitly defined against largely Western, modern, print texts and their contexts. It has, however, been found useful in medieval studies, to describe features including the form of transcription (as prompted, in fact by Genette's remarks in *Paratexts*, p. 3), inks, rubrication, illustration, glosses and commentaries. For a contextually specified approach to paratexts in the middle ages, see Charlotte Cooper, "What is a Medieval Paratext?", *Marginalia*, vol. 19, 2015, p. 37–50.

19. Ellen McCracken, 'Expanding Genette's Epitext/Peritext Model for Transitional Electronic Literature: Centrifugal and Centripetal Vectors on Kindles and iPads', *Narrative*, vol. 21, no. 1, 2013, pp. 105–24 (pp. 105–7).

20. McCracken, 'Expanding Genette's Epitext/Peritext Model', pp. 118–21.

21. Anthony K. Cassel, 'Beasts, The Three', in Richard Lansing (ed.), *The Dante Encyclopedia*, Garland, New York, 2000, pp. 85–9.

22. Lino Pertile, 'Contrapasso', in *Dante Encyclopedia*, pp. 219–22.

Singing the Second Realm: The Beginnings of *Purgatorio*

1. Jacques Le Goff, *The Birth of Purgatory*, trans. Arthur Goldhammer, paperback edn, Scolar Press, Aldershot, 1990, pp. 154–76.

2. Le Goff, *The Birth of Purgatory*, pp. 191–201.

3. Le Goff, *The Birth of Purgatory*, pp. 237–88.

4. On this and other 'vertical' relationships between the cantos in each part of the *Commedia*, see George Corbett and Heather Webb (eds), *Vertical Readings in Dante's 'Comedy'*, 3 vols, Open Book Publishers, Cambridge, 2015–17.

Further Reading

Illustrations and Illustrated Versions of the *Commedia*

Mary Jo Bang (trans.), *Dante Alighieri: Inferno*, drawings by Henrick Drescher, Graywolf Press, Minneapolis, 2012.

Lucia Battaglia Ricci, *Dante per immagini: Dalle miniature trecentesche ai giorni nostri*, Einaudi, Turin, 2018.

Seymour Chwast (adaptor), *Dante's Divine Comedy*, Bloomsbury, London and New York, 2010.

Leah Dickerman, Kevin Young and Robin Coste Lewis, *Robert Rauschenberg: Thirty-Four Illustrations for Dante's Inferno*, MoMA, New York, 2017.

Robert Hollander and Jean Hollander (transs), *The Divine Comedy*, illustrated by Monika Beisner, 3 vols, Edizioni Valdonega, Verona, 2007.

Hell. Dante's Divine Trilogy Part One. Decorated and Englished in Prosaic Verse by Alasdair Gray, Canongate, Edinburgh, 2018.

Purgatory. Dante's Divine Trilogy Part One. Decorated and Englished in Prosaic Verse by Alasdair Gray, Canongate, Edinburgh, 2019.

Guido Martina and Angelo Bioletto, *L'inferno di Topolino*, in *I classici della letteratura Disney*, no. 3, Milan, RCS Quotidiani, 2006, pp. 17–89.

Tom Phillips (trans.), *Dante's Inferno*, illustrated by Tom Phillips, Talfourd Press, London, 1983.

Robert Pinsky (trans.), *The Inferno of Dante: A New Verse Translation*, illustrated by Michael Mazur, Farrar, Straus & Giroux, New York, 1994.

Marcus Sanders and Sandow Birk (adaptors), *Dante's Divine Comedy*, illustrated by Sandow Birk, Chronicle Books, San Francisco, 2004–5.

Heinrich Schulze-Altcappenberg, *Sandro Botticelli: The Drawings for Dante's Divine Comedy*, Harry N. Abrams, New York, 2000.

Sebastian Schütze and Maria Antonietta Terzoli, *William Blake: Dante's Divine Comedy*, reprint, Taschen, Cologne, 2019.

Introductions to Dante

Zygmunt Barański and Simon Gilson (eds), *The Cambridge Companion to Dante's 'Commedia'*, Cambridge University Press, Cambridge, 2018.

Peter Hainsworth and David Robey, *Dante: A Very Short Introduction*, Oxford University Press, Oxford, 2015.

Rachel Jacoff (ed.), *The Cambridge Companion to Dante*, 2nd edn., Cambridge University Press, Cambridge, 2007.

Guy Raffa, *The Complete Danteworlds: A Reader's Guide to the Divine Comedy*, University of Chicago Press, Chicago, 2009.

John A. Scott, *Understanding Dante*, The William and Katherine Devers Series in Dante Studies, vol. 6, University of Notre Dame Press, Notre Dame, Indiana, 2004.

Prue Shaw, *Reading Dante: From Here to Eternity*, Norton, New York, 2014.

Works on Dante, Dante Illustration and Reception

Aida Audeh and Nick Havely (eds), *Dante in the Long Nineteenth Century: Nationality, Identity, and Appropriation*, Oxford University Press, Oxford, 2012.

Antonella Braida, *Dante and the Romantics*, Palgrave Macmillan, London, 2004.

Antonella Braida and Luisa Calè (eds), *Dante on View: The Reception of Dante in the Visual and Performing Arts*, Ashgate, Aldershot, 2007.

George Corbett and Heather Webb (eds), *Vertical Readings in Dante's 'Comedy'*, 3 vols, Open Book Publishers, Cambridge, 2015–17.

Silvia De Santis, *Dante and Blake: A Study of William Blake's Illustrations of the Divine Comedy Including his Critical Notes*, Cangemi Editore, Rome, 2017.

Simon Gilson, *Dante and Renaissance Florence*, Cambridge University Press, Cambridge, 2005.

Manuele Gragnolati, Fabio Camilletti and Fabian Lampart (eds), *Metamorphosing Dante: Appropriations, Manipulations, and Rewritings in the Twentieth and Twenty-First Centuries*, Cultural Inquiry, no. 2, Turia + Kant, Vienna, 2011.

Peter Hainsworth, 'John Dickson Batten's Illustrations to the *Inferno*', in Guido Bonsaver, Brian Richardson and Giuseppe Stellardi (eds), *Cultural Reception, Translation and Transformation from Medieval to Modern Italy*, Legenda, MHRA, Cambridge 2017, pp. 239–56.

Nick Havely, *Dante's British Public: Readers and Texts, from the Fourteenth Century to the Present*, Oxford University Press, Oxford, 2014.

Richard Lansing (ed.), *The Dante Encyclopedia*, Garland, New York, 2000.

Jacques Le Goff, *The Birth of Purgatory*, trans. Arthur Goldhammer, paperback edn, Scolar Press, Aldershot, 1990.

Elena Lombardi, '"A Gallehault was the book": Francesca da Rimini and the Manesse Minnesanger Manuscript', in *Mediaevalia*, 35, 2014, pp. 151–76.

Benjamin Martin, 'Celebrating the Nation's Poets: Petrarch, Leopardi, and the Appropriation of Cultural Symbols in Fascist Italy', in Roger Crum and Claudia Lazzaro (eds) *Donatello Among the Blackshirts: History and Modernity in the Visual Culture of Fascist Italy*, Cornell University Press, Ithaca, New York, 2005, pp. 187–202.

Anne O'Connor, 'Dante Alighieri – from Absence to Stony Presence: Building Memories in Nineteenth-Century Florence', *Italian Studies*, vol. 67, issue 3, 2012, pp. 307–35.

Rachel Owen, 'Dante's Reception by 14th- and 15th-century Illustrators of the *Commedia*', in Claire E. Honess (ed.), 'Current Trends in Dante Studies', *Reading Medieval Studies*, vol. XXVII, 2001, pp. 163–225.

Rachel Owen, 'The Image of Dante: Poet and Pilgrim', in Braida and Calè, *Dante on View*, pp. 83–94.

Deborah Parker and Mark Parker, *Dante Revealed: From Dante to Dan Brown*, Palgrave Macmillan, London, 2013.

Veronica Pesce, '*Beata Beatrix*: la Vita Nuova e i quadri di Dante Gabriel Rossetti', *Dante e l'arte*, vol. 2, 2015, pp. 201–26.

Robert Pinsky and Michael Mazur, 'A Conversation about *The Inferno of Dante*', in *The Harvard Review*, no. 8, 1995, pp. 60–71.

Martina Piperno, *L'antichità «crudele»: Etruschi e Italici nella letteratura italiana del Novecento*, Carocci, Rome, 2020.

Joshua Reid, 'Textual Physiognomy: A New Theory and Brief History of Dantean Portraiture', *California Italian Studies*, vol. 6, issue 1, 2016, unpaginated <https://escholarship.org/uc/item/2519f0xw>

Diego Saglia, 'Translation and Cultural Appropriation: Dante, Paolo and Francesca in British Romanticism', *Quaderns. Revista de traducció*, vol. 7, 2002, pp. 95–119.

Luigi Scorrano, 'Il Dante "fascista"', in *Deutsches Dante-Jahrbuch*, vol. 75, issue 1, 2000, pp. 85–124.

Manuela Soldi, 'Esporre il femminile. L'*Esposizione Beatrice* (Firenze, 1890)', *Ricerche di sconfine*, vol. VI, no. 1, 2015 <www.ricerchedisconfine.info>

Julia Straub, *A Victorian Muse: The Afterlife of Dante's Beatrice in Nineteenth-Century Literature*, Bloomsbury, London, 2009.

Julia Straub, 'The Transatlantic Dante in the Nineteenth Century: Cultural Authority and Reception Histories', in Erik Redling (ed.), *Traveling Traditions: Nineteenth-Century Cultural Contexts*, de Gruyter, Berlin, 2016, pp. 79–93.

Bruno Tobia, 'La statuaria dantesca nell'Italia liberale: tradizione, identità e culto nazionale', *Mélanges de l'Ecole française de Rome. Italie et Méditerranée*, vol. 109, no. 1, 1997. pp. 75–87.

Paget Toynbee, *Britain's Tribute to Dante in Literature and Art: A Chronological Record of 540 Years (c. 1380–1920)*, Humphrey Milford for the British Academy, London, 1921.

Kathleen Verduin, 'Dante in America: The First Hundred Years', in Michele Moylan and Lane Stiles (eds), *Reading Books: Essays on the Material Text and Literature in America*, University of Massachusetts Press, Amherst, 1996, pp. 16–51.

Heather Webb, 'Botticelli's Illustrations of Dante's *Paradiso*: The Construction of Conjoined Vision', *I Tatti Studies in the Italian Renaissance*, vol. 22, no. 2, 2019, pp. 187–208.

Other Works

Charlotte Cooper, 'What is a Medieval Paratext?', *Marginalia*, vol. 19, 2015, pp. 37–50.

Gérard Genette, *Paratexts: Thresholds of Interpretation*, trans. Jane E. Lewin, foreword by Richard Macksey, Cambridge University Press, Cambridge, 1997, pp. 1–3. Originally published as *Seuils*, Éditions du Seuil, Paris, 1987.

Ellen McCracken, 'Expanding Genette's Epitext/Peritext Model for Transitional Electronic Literature: Centrifugal and Centripetal Vectors on Kindles and iPads', *Narrative*, vol. 21, no. 1, 2013, pp. 105–24.

Irina O. Rajewsky, 'Intermediality, Intertextuality, and Remediation: A Literary Perspective on Intermediality', *Intermédialités*, no. 6, 2005, pp. 43–64.

Picture Credits

Index

References to illustrations are in *italics*

First published in 2021 by the Bodleian Library
Broad Street, Oxford OX1 3BG
www.bodleianshop.co.uk

ISBN: 978 1 85124 570 3

Publisher: Samuel Fanous
Managing Editor: Deborah Susman
Editor: Janet Phillips
Picture Editor: Leanda Shrimpton
Production Editor: Susie Foster
Designed and typeset by Dot Little in 11/18 Freight Text
Printed and bound in Wales by Gomer Press Limited on 150gsm Arctic
matt paper

British Library Cataloguing-in-Publication Data
A CIP record of this publication is available from the British Library